MASTERING HDR

COMBINING TECHNOLOGY AND ARTISTRY TO CREATE HIGH DYNAMIC RANGE IMAGES

PHOTOGRAPHY

MASTERING HDR

COMBINING TECHNOLOGY AND ARTISTRY TO CREATE HIGH DYNAMIC RANGE IMAGES

PHOTOGRAPHY

MICHAEL FREEMAN

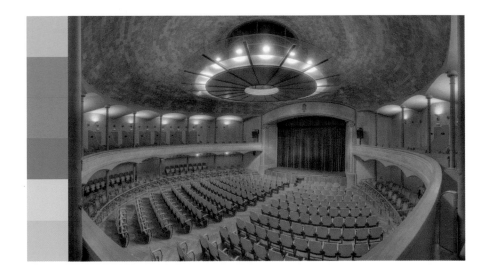

AMPHOTO BOOKS

First published in 2008 by Amphoto Books,
an imprint of Watson-Guptill Publications,
Nielsen Business Media, a division of
The Nielsen Company
770 Broadway, New York, NY 10003
www.watsonguptill.com
www.amphotobooks.com

Library of Congress Control Number:
2007942896

ISBN-13: 978-0-8174-9999-0
ISBN-10: 0-8174-9999-7

Printed in China

1 2 3 4 5 6 7 8 9 / 15 14 13 12 11 10 09 08

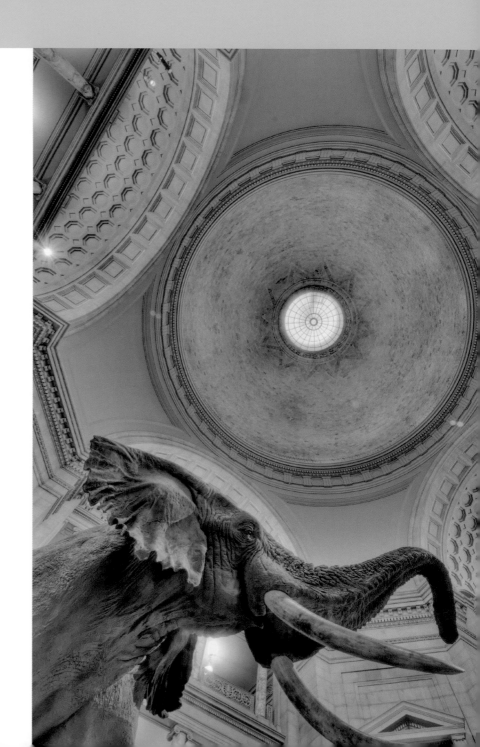

Contents

Introduction

I make no apologies in this book for going strongly technical and detailed. HDR demands this kind of attention in order to get worthwhile results. But what results! Among other things, HDR makes the following possible: you can restore highlights and shadows from any situation, you can shoot in harsh light with a good chance of success, you can achieve remarkable tonal and color results never before possible, and you can shoot without any photographic lighting whatsoever.

Does HDR sound like a magic bullet for photography? It may well be, although there are limitations and a price to pay. The subject needs to be more or less stationary, as does your camera, and it calls for a considerable amount of careful work on the computer. So, it is not for everyone, but if you can put up with both of these conditions, HDR will open up a world of new subjects and a level of control over the image that far exceeds even the techniques of Ansel Adams — and in color.

This is where photography, heavyweight computing and the study of human visual perception meet. Heady stuff, and it's both new and developing. There are two distinct parts to HDR photography: shooting and processing. The former is consistent, but the latter varies wildly according to the software program. As a result, with processing there is no alternative but to get right down to specific cases, step by step, and this is largely the model for this book. This is, in any case, much easier to follow than theory, although I've included some of this too, early on.

Welcome to something quite new to photography — the ability to create images of scenes exactly as you think you see them, or exactly as you would like them to be.

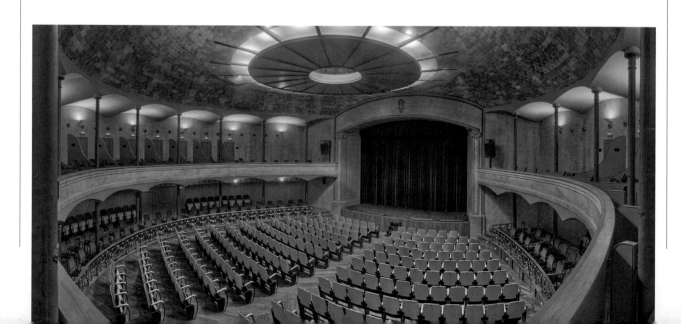

HDR **scenes & vision**

Step back for a moment from photography and images, and consider the range of brightness in the real world. Clearly, it can be much greater than you could ever experience looking at a picture taken from it. This, of course, is the essential problem when dealing with brightly lit scenes that have strong shadows. In traditional photography it was dealt with by sacrificing detail, or by not taking that particular image, rather than waiting for another time or another point of view. And yet we cope very well with looking at any scene. The mechanisms in the eye and brain are complex, but they have a lot to teach us in making decisions about capturing and outputting HDR images.

To quote one researcher in the field, Reinhard, "Reproducing the visual appearance is the ultimate goal in tone mapping." This sounds right on target for photographers, but actually falls far short of our needs. Or rather, our needs as photographers are tangential to the main thrust of the work. Human vision is an immensely complex and still incompletely understood subject. It involves both the physiology and psychology of perception, and many of the necessary measurements in both areas have yet to be made. As a result, this is a field where, perhaps surprisingly to non-academics, there is still little agreement on many of the key mechanisms.

As photographers, we generally have our own ways of thinking about seeing, and about the effects of our imagination and techniques on viewers' reactions when they first see the image. These ways of thinking about perception are very different from the academic way. To a creative person, whether photographer, painter, or whatever, it must often seem that a scientific approach to imaging, with its reliance on testing, measurement, mathematics and rigorous proof, is soulless. It is as if trying to reduce the mysteries and pleasures of visual creativity to a set of formulae, but doing this in vain because there are too many things that cannot be quantified. This suspicious view of science and imagery is based on a fundamental concern — that a successful analysis of how images work would challenge the very essence of what we try to do, which is to make surprising, powerful, arresting images, at least when we're working at full capacity.

Well, that is a common enough view, but unnecessarily biased against the research and technology that actually makes photography possible. Many researchers in the field of perception have their own counter-view, which is that many of the uninformed opinions and judgments passed on the subject are just plain wrong. If you'd like to explore your sympathy for this view, look no further than some of the online forums that discuss HDR!

Light, luminance, and reflectance

Images with a high dynamic range are the subject of this book, and while we'll look at the concept in detail, it is fairly self-explanatory.

Scenes vary in their range of brightness, and the ones that cause the most trouble for photography are those in which the highlights are much brighter than the shadows. In dealing with this it's important to understand the definitions. In the science of measuring light, called radiometry, there are many quantities and definitions, but most of them are unimportant for practical photography. However, it is important to understand the following: brightness, lightness, luminance, and reflectance. This is because many HDR software applications attempt to isolate one or another of these and work on them separately.

Light is radiant energy, that we experience through the human eye, which has pigments and other factors that makes us sensitive to some wavelengths more than to others. Radiometry is the science of measuring light; photometry is the science of measuring light weighted according to human vision. The most important quantity in HDR imaging is luminance, which is an approximate measure of how bright a surface appears. Luminance is the measurement

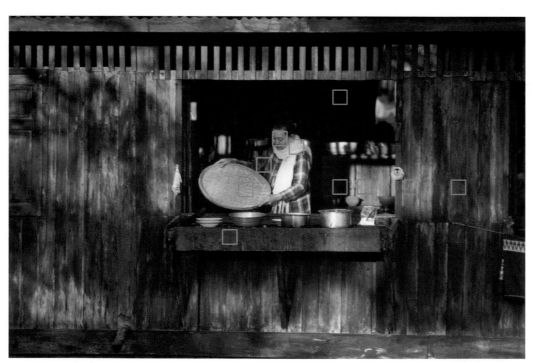

Contrast from illumination rather than surfaces

A roadside shop in Burma selling food. The unpainted wood is identical in its surface inside and out. Green squares mark different lighting on this same surface, blue squares the same lighting on different surfaces.

used in the workings of HDR software. Brightness, however, is the term that most of us use, and is the sensation our eyes receive from an area that seems to emit light — more of it or less of it. It is perceptual, not objective, and so unlike luminance there is no clear measurement. When we talk about brightness, it is to describe the appearance, and as long as no measurements or numbers are involved, it is reasonably interchangeable with luminance.

Lightness is also perceptual, but because it takes into account the eye's nonlinear response to brightness (roughly logarithmic), it can be quantified. A surface that reflects just 18% of the light falling on it actually looks mid-gray, meaning half as dark as white. You can also think of it as relative brightness. Again, it is used in this book to describe appearance, more or less interchangeably with brightness.

Reflectance is the ability of surfaces to pass on some of the light that falls on them. In the course of doing this, the surfaces modify the light in various ways. One obvious and essential fact when it comes to high dynamic range scenes is that the range of possible brightness between different surfaces under the same light is quite narrow. The difference between a pure white surface and a pure black surface next to each other in the same lighting is about 30:1, no more. The huge differences in the high dynamic range images we deal with in this book come from the illumination. The photograph (opposite) of the Burmese sidewalk shop illustrates the difference.

Nevertheless, this problem has furnished a kind of solution for the major issue in HDR, which is how to compress the wide range of real-life scenes so that they can be viewed on a screen or on paper. As we'll see in Chapter 3, if it were possible to separate luminance from reflectance, we could compress the former and preserve the latter. This sounds like an impossible task, but there are ways of getting close to it, by making some assumptions.

Working with luminance only

Although most of the time we work on images in RGB color space, so-called color opponent spaces have some great advantages, not the least being that they deal with color separately from luminance—which is the way our eyes work. One of the most accessible is Lab (sometimes written L*a*b), and the name color opponent comes from the fact that all the color information is contained in just two channels that oppose each other. Each channel covers a different color axis. The a channel goes from yellow to blue, and the b channel from red to green. This is one of the ways in which images are processed in the eye, after they have been recorded by the photoreceptors, and, incidentally, why we can talk about a reddish yellow but never a reddish green.

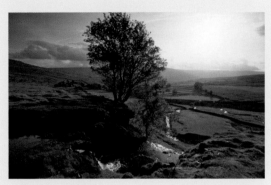

The full image, all channels

In Lab, the Luminance channel

The a channel

The b channel

Dynamic range of scenes

The range of light falling on a subject can vary much more than the reflectivity of surfaces.

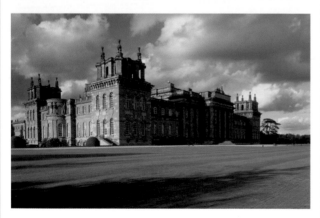

Low dynamic range
The low range in this scene of a green hillside is ensured by the lighting (cloudy day, no shadows) and the framing, which excludes the sky.

Medium-high dynamic range
Bright sunshine creates most of its contrast by shadows, but is enhanced at the upper end of the scale here, in a view of an English country estate, by the reflectivity of white clouds.

Nevertheless, add the two together and the dynamic range is potentially very high. On a cloudy bright day in mid-latitudes (see picture top left), the normal exposure setting for a camera set to ISO 100 will be around 1/125 sec at f5.6, or EV12. If there is nothing pure white and brightly reflecting white in view, nor strong mirror-like reflections of the sky, nor the sky itself, the entire range will fit comfortably into the range that can be captured by the sensor, which is about 9 f-stops. In other words, there is no clipping of either highlights or shadows. These are the kinds of lighting conditions that digital sensors (and slide film for that matter) deal with easily. The dynamic range is low (if we ignore the barn doorway), about one order of magnitude, 4 f-stops. (Most photographers are more familiar with f-stops, so to roughly translate, think of one order of magnitude as about 3½ stops.

However, clear the clouds away and on a day free from haze, smoke, or pollution the average exposure will rise by about two stops — and the dynamic range more so. Zoom out to include the sky and it rises higher. Adding bright white clouds might add another f-stop of range, reaching about 3 orders of magnitude, possibly 10 f-stops. Shooting into the light adds yet more, as the horizon is brighter and there are likely to be deeper

Approximate luminance values (cd/m²)		
Starlight	0.001	10^{-3}
Moonlight	0.1	10^{-1}
Indoor lighting	100	10^2
Indoor daylight	100	10^2
Cloudy day	2,000	2×10^3
Open shade	10,000	10^4
Bright sunlight	100,000	10^5
Disc of the sun itself	100,000,000 – 1,000,000,000	$10^8 – 10^9$

Dynamic range of lights ad devices

Scene	Luminance range	cd/m²	ƒ-stop range equivalent
Full range from the sun itself to starlight	1,000,000,000,000:1	10-3 — 109	40 stops
Full range of human vision with dark adaptation	100,000,000:1	10-3 — 105	27 stops
Dim interior with view through window to bright sunlight	5,000-10,000:1	10-2 — 105	12-14 stops
Human vision: single view	10,000:1		13-14 stops
B/W negative film	10,000:1		13-14 stops
Typical DSLR at base sensitivity	500:1		9 stops
LCD monitor	350:1		8-9 stops
CRT monitor	200:1		7-8 stops
Paper: best possible	100:1		7 stops
Paper: typical	50:1		5-6 stops

shadows facing you. Finally, include the sun in the view, and the dynamic range will be about as high as possible in full daylight—perhaps 106.

The sun itself, with a luminance of 108 to 109 (cd/m²—candela per square meter) when well above the horizon, sets the upper limit for dynamic range—and a high limit at that. Even so, the dynamic range of a single scene can be increased further by including even darker shadows than you might find outdoors. Move indoors, yet still with a view out, and you can increase the range by another order of magnitude. If, say, there is a white surface outside reflecting bright sunlight, the dynamic range from inside is likely to be more than 3 orders of magnitude, meaning possibly 12 to 15 stops of range.

So, at what point does a scene qualify as HDR? And perhaps even more important, at what point does it merit HDR shooting and tonemapping? This is not a simple issue, because HDR tonemapping can be applied to any image at all, including single frames, whatever dynamic range they cover. This becomes as much a matter of taste and opinion as of necessity, and there is already a fashion for giving extreme tonemapping treatment to images that don't need it, simply for the unusual effect. Here I'm going to promote the view that, generally, HDR is best reserved for scenes that really do have too high a dynamic range to capture normally.

◄ **High dynamic range**

Shooting into the sun increases the contrast even more, by adding to the top end of the scale and increasing the area of shadow facing towards the camera.

▼ **Very high dynamic range**

Including a bright sun in frame gives the highest possible range for a daylight scene, around 7 orders of magnitude.

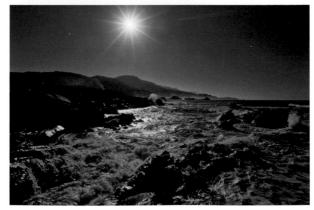

Dynamic range of capture sensors

For more than a century of photography the basic issue of not being able to capture or show the full range of brightness in the real world has simply been accepted as a fact of life.

An inconvenient fact of life, to be sure, with various workarounds, but not an essential problem. There have been a number of "solutions," but generally these have not been seen as part of a concerted effort to record everything possible. One technique invented in the darkroom was dodging and burning, the former to open up shadows, the latter to recover highlights. Another was adding lighting to fill in darker parts of the scene, whether an interior looking toward a bright window, or fill flash to prevent a portrait becoming a silhouette. Yet another, if you could even call it a solution, was to compose the frame to minimize high contrast, or even to wait for a different time of day or weather.

What makes HDR an issue worth considering is the new digital possibility of tackling it effectively. HDR imaging now makes it worth considering a view and a photographic treatment that might simply have been earlier dismissed as "too contrasty." The first part of the problem now are the limitations of the camera sensor. These limitations, I should stress at the start, are simply those of current technology. There is no reason in principle why a camera sensor couldn't capture a much greater range than it does; we simply haven't reached that stage of development. Work continues on this front, as we'll see, and there's little doubt that eventually one of the main topics in this book — capturing an image in several exposures — will be a thing of the past.

Before looking at modern sensors, it's worth bearing in mind that high dynamic range capture has been possible for decades — with black-and-white negative film. A fine-grained

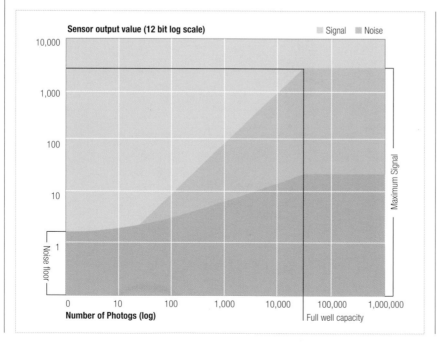

Sensor output value (12 bit log scale) ■ Signal ■ Noise

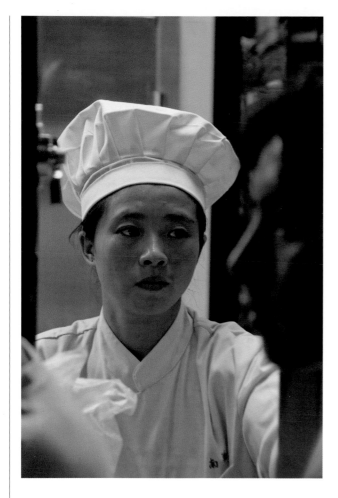

The noise floor

This photograph of a cook in Shanghai was shot as ISO 800, and at this sensitivity noise is present, but not insistent at normal processing and a normal viewing distance (see the detail of the shadows behind her shoulder). However, increasing the Exposure value in a Raw converter is the acid test for noise, and this increase of the equivalent of 2.5 stops shows that the real dynamic range captured does not extend far into the shadows. (This is explored on page 18.)

panchromatic film can capture up to 4 orders of magnitude of brightness, close to that of human vision in a single view. This is 104, or 10,000:1. If this surprises, consider that the key darkroom skills, as well as the range of paper grades and special film-processing techniques, were devoted to compressing a very large range of image information into the short range of photographic paper. Ansel Adams's Zone System was aimed partially at the same goal, sufficiently to be considered one of the earliest tonemapping methods. In other words, HDR is not quite as new as many people think. This might prompt you to think that tonemapping, the subject of Chapter 3, could be applied to black-and-white negatives — and it can, as I'll show on page 115.

104 may not be the full dynamic range desired (we really need 108 or 109 to cover all situations), but it certainly qualifies, and is very much better than a current digital camera sensor, which cannot even reach 103 (1000:1).

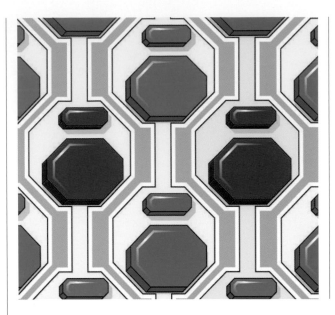

**▲ Double photodiode
for greater range**

The octagonal main photodiodes in Fujifilm's sensor
design are more closely packed than the conventional
rectangular, but also allow room for a second, smaller
photodiode that is less likely to become overexposed.

One of the key ways in which black-and-white negative
film manages to capture such a wide range is that its
response to light is, like human vision, non-linear. The
characteristic curve of a typical film is straight (that is,
linear) for only a short part in the middle, where the
mid-tones lie. At the top and bottom, where the
highlights and shadows are, the slope gently curves
away, meaning that the film manages to capture extra,
if faint, highlight and shadow detail.

Digital sensors have no such gentle tailing-off in
response. Their photosites, like wells, simply fill up
in proportion to the light striking them. When they
fill to the top, there is no subtle shading information
recorded at all, just pure white. To clear up any confusion
about dynamic range and bit depth, the number of
bits determines the precision of the capture — how many steps the range
of brightness can be recorded as. In other words, a 14-bit sensor is more
accurate than a 12-bit sensor. Though it might, it does not necessarily capture
a wider range, but more detail within the range. The real limit to the range
of a sensor is the amount of noise in the shadows. Even when no light has
been captured, there is still some noise present. There are different causes
of noise, including high ISO sensitivity and long exposures, but the noise
produced is always most evident in the shadows. When the noise exceeds real
image detail, this is the lowest useful end of the sensor's dynamic range — the
"noise floor" in other words. Some camera sensors are "noisier" in this
respect than others, but they are all susceptible to some degree. The analogy
with audio would be when the hiss in a broadcast transmission drowns the
actual recording. This is sometimes expressed as the signal-to-noise ratio;
the higher it is, the "cleaner" the image, but a ratio of 1:1 is the noise floor.
The human visual system, incidentally, also suffers from the same limitation,
with a signal-to-noise ratio of about 32:1.

As the graph (see page 14) shows, even though the top end of the
brightness range captured — the full well capacity — may be high enough to
suggest a dynamic range of more than three orders of magnitude, the noise
floor is typically high enough to make the effective dynamic range of even a
good digital SLR no more than about 500:1.

One of the arguments for shooting Raw format images rather than TIFF or JPEG is that it retains the extra information from the original 12-bit or 14-bit capture, rather than have this discarded in the camera to make an 8-bit TIFF or JPEG. Opened in, say, Adobe ® Photoshop ®, the Raw file appears as 16-bit, which fools some people into thinking that the extra two or four bits per channel, and potentially 4 extra stops of range, are somehow magically present. The reality is less exciting. The 12-bit or 14-bit Raw is simply opened in a 16-bit format, since 8-bit and 16-bit are more logical numbers for computer architecture to process and to move to 8-bit would necessitate discarding data, leaving 16-bit as the practical choice. Similarly you can convert an 8-bit image any time you like to 16-bit. Nothing new is added. As already explained, the dynamic range captured depends on the design of the sensor. Camera and sensor manufacturers continue to develop and improve the design, and higher dynamic range is one of the goals. As an often-mentioned example, Fujifilm's Super CCD SR II sensor features a large and a small photo-diode in the same photosite to achieve a better dynamic range. The smaller photo-diode collects more highlight detail by being less responsive to light than the primary. Once the large photo-diode has filled up, the smaller one takes over, capturing more highlight detail. For example, when the primary is at 60% full, the secondary is still only 10% full, but when the primary is at 100%, with all highlights blown out, the secondary still has capacity. The two signals are read separately and combined for a single pixel value. The manufacturer claims a 4x greater dynamic range than conventional from this system.

◢ Recovery from a Raw converter
Modern Raw converters use various algorithms to improve the dynamic range during processing. At the highlight end, Photoshop's Recovery slider works by reconstructing information present in one or two channels across all three. In the shadow detail, an "Exposure" increase of 3 stops from "normal" reveals significant chrominance noise (center), but by default the Raw converter processes this out (right).

Dynamic range of displays

If camera sensors fail to handle the full range of brightness in a high-range scene, the problem gets even worse with the final stage of photography — displaying the image.

The two ways of displaying the vast majority of photographs are a monitor screen and paper print, and neither come anywhere near the captured tonal range. A cathode-ray tube (CRT) display has a dynamic range of 200:1 or less, and even a modern liquid-crystal (LCD) display is only a small improvement, up to 400:1 at best. Paper prints are much lower, at best 100:1.

LCD displays have now taken over almost completely from CRTs, and have the advantage in dynamic range that they don't suffer from a maximum brightness limit (with a CRT the maximum is set by the unsafe amount of X-rays emitted by the phosphorescent pixels being bombarded with energy). However, unlike a CRT pixel, which can be switched off completely, an LCD pixel leaks some light, and this limits the dynamic range.

New technology shows real promise. Currently, LCD displays use a uniform backlight, but a new design by Brightside Technologies replaces this with a honeycomb array of light-emitting diodes (LEDs). By varying the light output from each of these individually, a fully high dynamic range becomes possible, in excess of 200,000:1. The effect mimics real-world brightness values remarkably, and the only drawback (admittedly a considerable one) is the high cost of the high-output LEDs. These costs will come down eventually, however.

The Brightside hardware solution effectively solves the major problem of HDR, but only for monitor views. The display of choice for many photographers, certainly for images considered special, will always be a print. Indeed, in most people's minds, photograph means print, with everything else just a stage in the process of making one. Prints are almost always viewed in even illumination, which means that their dynamic range is set at one end by how much of the light the paper can reflect, and at the other end by the combination of maximum pigment absorption and minimum reflectance. Pure white paper reflects about 90% of the light, while maximum absorption in a black pigment is about 99.5%, and the result is a dynamic range of around 100:1, less in many cases, particularly with a textured surface such as heavy photo rag. The situation is complicated somewhat with glossy paper,

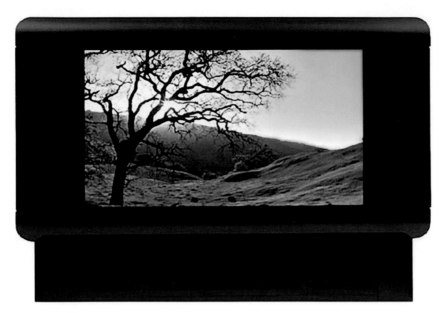

which appears to have a higher range but only because a changing angle of view (tilting the print or walking around it) allows the shadow areas to reflect ambient surroundings.

In summary, as we move from the real world to the camera to a computer monitor and finally to a photographic print, as described over the last few pages, the sequence sounds like a depressing loss of capacity. This is, however, the problem that HDR with tonemapping attempts to solve. It's also important to remember that human perception is highly complex and very adaptive. When we look at a normal, low dynamic range print, provided that it has been competently made, we don't sense any failure. On the contrary, a good print of a well-exposed image may well have much of the vibrance and richness of what we imagine the original must have been like. For instance, an Ansel Adams print made by himself (quite different, incidentally, from the same image printed in a book, however well), is a remarkable evocation of the range of light. The complex mechanisms of perception lead us to expect, and therefore see, different things according to how they are presented. In other words, the problem is rarely as bad as the numbers make it seem, and I'll return to this later when we look at which situations call for HDR treatment. As we'll see, this is not all lighting situations by any means. Applying HDR methods to each and every scene is not only pointless but formulaic, which is worse.

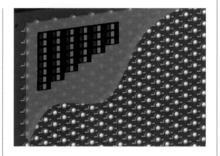

▷ HDR display
The Brightside DR37-P HDR display is currently the only monitor with a dynamic range sufficiently high to display HDR images without them needing tonemapping. Its output reaches 3,000 cd/m2, and its blacks are significantly lower than those of a conventional monitor.

▷ LED backlighting
The method used for achieving HDR in display is individually controlled LEDs as a dynamic backlight for the LCDs at the front. Each LED operates independently, as opposed to the single illuminance of a conventional design. It is a method being aggressively researched by television and monitors manufacturers like Sony, as well as more specialist groups.

Contrast and gamma

HDR inevitably involves contrast, and it's important to get the definitions right at the start.

Contrast is usually defined as the ratio between the brightest and darkest areas in an image, but in recent years, research into the way we perceive images (and into computer imaging) has muddied the waters. The response curve needs no introduction; adjusting Curves in Photoshop — Input/luminance of the scene from left to right, Output/brightness of image from bottom to top. The traditional way of judging contrast is from the angle of slope, with the default 45° as average. Or more accurately, the angle of slope of the middle section, where most of the middle tones are. The steeper the slop, the higher the contrast — but this is the traditional, overall contrast.

Now, by definition, a high dynamic range scene must contain very high contrast. The issue, however, is how this contrast is distributed, because while there may be a massive difference in brightness between the darkest shadow and the brightest highlight, there may be substantial areas inside the image where the contrast is normal or low. The example here shows such a case. Where the sun strikes the rocks, the contrast is, of course, high, as it is

The original image with its histogram. The shadow areas and highlight areas are fairly well separated. Black circles mark areas with the same mid-tone luminance value (56) and yellow circles mark the same shadow value (20).

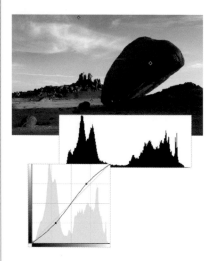

Applying a standard contrast-raising S-curve affects the entire image. Black circle values move to 59, yellow circle values to 14. The range in the histogram is stretched left and right.

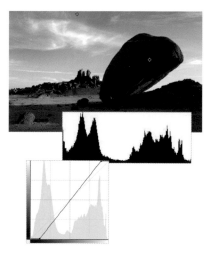

Dragging in the end-points gives the same steeper slope as before, but the highlights and shadows are now clipped — a much more aggressive overall contrast. Black circle values move hardly at all to 58, yellow circle values to 10. The range in the histogram is stretched even more, with values lost at far left and far right.

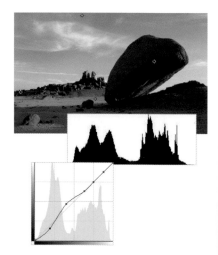

The upper highlights are anchored and an S-curve applied to the shadows only, raising contrast there alone. Black circle values move a little to 63, yellow circle values to 17.

between the sky and the land. But within the shadows of the perched boulder, for example, the contrast is very low.

This is where one of the key concepts in HDR imaging comes into play, the distinction between global contrast and local contrast. We are used to thinking, in traditional photographic terms, of just one kind of contrast, but there is a whole range. As we'll see on the following pages, an important feature of human perception is that we pay more attention to relative brightness than absolute brightness. In other words, we generally respond more to the contrast within a small area of the view in front of us than we do to the contrast across the entire scene.

The image I've chosen to illustrate this exhibits low dynamic range, and marked on it are black circles around small areas with the same mid-tone luminance value, 56, and yellow circles around small shadow areas (luminance value 20). Two factors come into play. One is the scale over which the contrast is viewed and adjusted, from across the entire image to very small distances. For instance, if you adjust a normal 8-bit or 16-bit image in Curves, and apply a standard S-curve, the contrast will be raised overall. If instead you drag the end-points inward, the contrast will be increased even more harshly, with clipping at either end (moving the end-points inwards in Levels does the same). In both cases, all of the image is affected, and this is

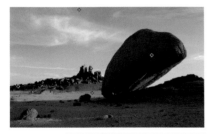

Shadow/Highlight is a local tonemapping method, with many ways of choosing how the contrast is affected. Here there is a slight overall lightening, but with contrast increased over neighborhoods of 133 pixel radius. Now the samples in the circles move independently. Notably, the neighborhood around the shadow tone in the middle of the large boulder is fairly even, so it is simply lightened a little to 25, while the neighborhood around the shadow on the left takes in the bright sky so that it is darkened slightly to 18 to increase contrast (the sky next to it has gone up from 76 to 83 also). Note that the overall basic shape in the histogram hardly changes, it is just shifted overall to the right because of the slight lightening, but the distribution of the peaks has been altered. In other words, no stretching.

Unsharp masking can also be used for tonemapping if the radius is set high enough. Here, the intensity is low at 15%, the radius high at 100 pixels, and a threshold of 3 set to prevent changes in similarly-toned areas. You can see that the biggest contrast change is across large transitions, such as the shadowed outlines of boulder and landscape against the sky, while there is no change at all in, for instance, the upper part of the sky. The red circle areas move hardly at all, nor does the shadow in the center of the boulder, but the left shadow, by the skyline, goes down to 15. The histogram shows very little change, apart from a slight bulging at left and right.

Three scales of contrast

Using filters to simulate different contrast scales, this image of a lighthouse has been processed in three different ways, with color removed to avoid distraction.

A Gaussian Blur at a wide radius of 60 pixels destroys all detail below that to give an approximation of the global contrast of the scene.

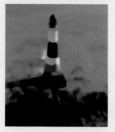

A Median filter at a 20 pixel radius averages out all small-scale detail below that for a blocky view representing the mid-scale contrast.

A Find Edges filter works on a scale of a few pixels only, emphasizing the detail at this scale. Contrast at this scale slides into assessments of sharpness (sharpening is by definition contrast enhancement on a fine scale).

the largest-scale contrast change that you can make. The samples in the red circles are shifted by the same amount, as are those in the yellow circles.

If, however, you begin by anchoring the upper and lower quarters of the curve by clicking points but not moving them, and then apply an S-curve in the middle, you will increase contrast in the mid-tones only. There are all kinds of variation on this, to limit the scale of the contrast changes. For instance, if you make a luminosity mask (by clicking the lower left icon in the Channels palette in Photoshop), this selects the brighter 50% of pixels, and applying a curve to this has an effect that is restricted to the highlights. Or, if you invert the selection, the effect is restricted to the shadows. Still, pixels with the same value move by the same amount.

The second factor is whether the adjustments are made globally, as we've just discussed with Curves or Levels, or locally. Local tonemapping is at the heart of much HDR processing, and the principle (see Chapter 3) is quite different. It's enough to say for now that local contrast involves looking at the immediate surroundings of a tone and adjusting contrast in this area — the distinction is spatial. Local tonemapping is not exclusive to HDR, and one of the most widely used operators is the Shadow/Highlight tool in Photoshop. Applying this creates a different kind of contrast, with each area moving to a different value, depending on its surrounding neighborhoods of pixels. In the example on page 21 the radius has been deliberately set high, and you can see, for example, that the two shadow areas in the yellow circles have moved in opposite directions. On the left, the value has gone down slightly to 18, because it is affected by the sky next to it and contrast has been increased in relation to this, while on the right the value has gone up to 25.

If we combine the two different contrast factors together — scale and global-local — an enormous number

of combinations are possible. Changing the size of the neighborhood in a local operator changes the scale, but maybe this kind of effect will also be achieved by doing the calculations in quite a different way. One result when the software searches a small area of pixels, or else does something that affects the high frequencies, is to sharpen details, and the effect could be described as crisp. If the local area is very large, say 100 or 200 pixels, the effect is difficult to describe, although some might call it "punch." Describing the effects of all this new software is an issue in itself, faced by all software developers. Terminology apart, it's important to remember that the only thing that ultimately matters is the visual effect.

Gamma

Gamma is the sensitometric measurement of the angle of slope of the response curve shown on page 14. Specifically, it is the angle of the straight-line section (with density (D) on the vertical axis and exposure (log E) on the horizontal). This makes it a useful measure of contrast, but only for the central tones, not shadow or highlight. But gamma means more than this. It is a response function, and in digital imaging is particularly important for monitor displays, which vary. Gamma correction is a curve applied to make an image look acceptable to the human eye.

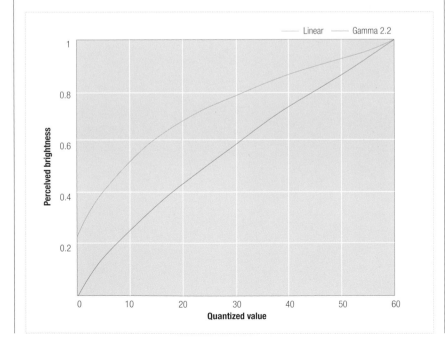

Gamma applied

Here is an example of how a raw digital image is typically processed to look "correct." Normally we never see this, because the processing takes place inside the camera, but the raw capture is linear. The first image shows how it would look if simply presented as captured—very dark. In the second image, a standard gamma correction is applied, a curve that drastically boosts the darker tones, but leaves the end points alone. Compare this with the third version, which is a curve applied manually in Photoshop.

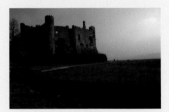

Original

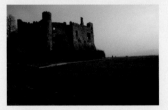

Standard Gamma

Photoshop Curves

The way we see light

Human vision and cameras face many of the same problems — a huge range of possible brightness levels, a less than ideal number of receptors packed into a small retina (or sensor), and the limited bandwidth of the optic nerve.

The way our natural system solves these problems has an impact on how photography can try to do the same.

The eye and brain adapt to changing levels of light, so as daylight fades, for example, the eye and brain keep pace, just as they do when we move from a bright place to a dark place, or vice versa. If you walk out from the subdued light of a room into bright daylight, after a few seconds of squinting and slight discomfort, you adjust to the raised level of luminance. The same thing happens when you shift your gaze from, say, the deep shade under a nearby tree, to bright sunlight. This adaptation is called "light constancy," where our perception of lightness remains roughly the same under different intensities of light.

Just as important is what light constancy implies — that we pay much more attention to the differences in how bright surfaces look next to each other than to the overall illumination. Our eyes adapt to the amount of light falling on a scene over a period of time, but at any one point what really counts is the difference between neighboring surfaces reflecting that light; the contrast. In other words, over large image regions we adjust to different brightness levels, but over smaller regions we do not. It is within these smaller regions in view that we are the most sensitive to contrast, and we can distinguish between contrast variations of about one percent.

Another issue that has an effect on all photography is what researchers call the anchoring problem. Given that the most important kind of contrast for us is relative contrast, how do we decide for any one scene what is white — the maximum brightness — and also what is black and what is a middle tone? It turns out from research that in any scene, we set the brightest value as white, even if in reality the surface is more a shade of gray. Moreover, the larger a surface, the lighter it

▼ Perception
Simulated views of different perceived elements of a scene (see caption opposite).

Luminance

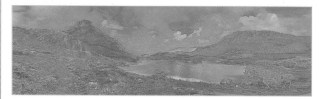

Reflectance

3D form

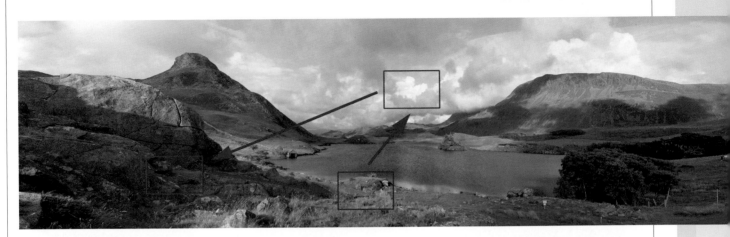

appears to be. So, if most of a scene is shadow area, it will nevertheless seem a little lighter, less dense, than if it covered a smaller area. The implications for photography and HDR tonemapping are that large dark areas call perceptually for more opening up than do small areas.

At the opposite end of the tonal range, distinguishing between different levels of "whiteness" can be an issue. There is the white of a white wall, but then there is also the white of something glowing from within, such as a photographic lightbox. Then there is the more intense white of a light source. If all of these are present in a single image, the tonemapping will need to be done very carefully. Even if you have captured all the detail of a lamp, it cannot sensibly look darker than any nearby bright surface.

▲ Distinguishing light falling from light reflected

A number of different researchers in the field of human vision believe that the visual system processes the variations in brightness into three "layers"—illumination, reflectance, and three-dimensional form. This panorama covers an angle of view of about 100°, more or less what we are aware of in a single view, though with much of it peripheral vision. The three versions opposite attempt to convey the effect. You can see that the main differences in brightness come from lighting, following the shadow edges, for instance. Light constancy comes into play when we look into these regions. When we look at the shadows (in real life), the impression of contrast and general brightness is the same as if we look at a sunlit area, and at the sky. And at the same time, we tend to group elements according to how far away they are.

Gestalt and perception

HDR and tonemapping allows us, given the right set of initial exposures, to reproduce any tone and any color in a picture in any way we choose.

This sounds wonderful, but it can also be a recipe for confused and bizarre results. The reason why I'm devoting so many pages to perception here at the start is that we need some kind of guiding principle for tonemapping, and that must surely be linked not only to the way we see, but to what we expect to see and feel comfortable with when we look at it.

Gestalt theory, developed among Austrian and German psychologists in the early 20th century, has had a resurgence in modern research into perception. At least parts of it have, and these are the parts that generally express a common sense view of how we organize the things that we look at in our brain. This is very valuable for tonemapping, because many of the Gestalt laws and principles cover ways of seeing that imaging software cannot mimic.

Gestalt theory posits the grouping of elements in an image based on factors that include proximity, continuation, common fate, similarity, and closure. But, more important, it takes into account subject matter, not just the points and shapes in an image, and takes a generally holistic view. Our eye and brain combined often make calculations based on what we know the subject to be. In

▲ Good Continuation
One of Gestalt theory's best known "laws" is that of Good Continuation, in which we assume that lines and edges continue even when this is not visually definite. In this view of a Bronze Age stone burial chamber, we assume that the large slab is perched on three triangular stones, because we can see part of them and it makes sense. The outline that we perceive is known. The outline that imaging software sees, however, is much more limited, as demonstrated by a Find edges filter.

the example to the right, we know that there is flag and that it is a single item, even though it is divided by the shadow line. If we were making any adjustments to the image, we would really want the values of the entire flag, light and dark, to move in the same direction.

One valuable discovery that dates back to Gestalt theorists in the 1930s is of regions in a scene that seem to work as units. Whatever is inside them has a "belongingness." They have been called fields, frameworks, and segments. They may be as simple as areas unified by lighting, such as anything inside the beam of a spotlight, but they may also be seen as enclosed units by their subject matter — everything on a table, for example. They may also be seen as grouped because they are at the same distance. The reasons may be varied and many.

The implication for tonemapping is that we often find an area in a photograph that we want to treat in its own way, so that all the things inside it remains related to each other. When the tonemapping software fails to identify such a region, we have more of a problem than usual in getting things to look right. To complicate matters, if there are several such unconnected areas in a scene we may still expect them to look similar in internal, local contrast. They may have a higher level of perceived grouping.

You can see where this is going. Once again, it is the local neighborhoods of tones and subjects in a scene, and in an image, that is of maximum importance to human perception. This is precisely what tonemapping does in the form of local operators. So, there are local areas and the overall picture, just as there is local contrast and global contrast. The balance of visual importance between local and overall can vary from image to image. This is worth remembering, because HDR tonemapping software generally allows the user to choose the bias — toward local or toward global.

Red flag
In color, we have no difficulty in recognizing this Chinese flag as a single unit, and even in black-and-white (top left) we reach the same conclusion, based on what we know about flags. We even assume that the pattern of wooden windows and wall decoration continues behind it (Gestalt Law of Good Continuation). Tonally, however, the flag is divided, as are the elements of the wall behind. Imaging software can judge regions within an image only on the tonal and color information, not on knowledge of the subject.

The way we see images

Reproducing a scene the way it looks to the eye is the stated aim of HDR techniques, but although this sounds plausible, it misses out on an important second layer of visual experience.

▲ Photograph as object
While we look into a photograph to view the image, we look at it as an object in its own right, as this view suggests. This affects our expectations.

When we look at a photograph, we not only look into the image to see what was captured, we also look at the image as a neatly bounded frame and object. We expect certain things from a print hanging on a wall, or in a book or magazine, or on a screen. First, there is the all-important field of view. Consider a real-world scene, without a picture in it. We inhabit this scene, it wraps around us, and while we can only focus on one part of it our eyes move constantly and our brain builds up a wide visual understanding of it. The sharply focused view is very limited indeed — just 2°, from the foveal region of the retina — and so the movements are necessary. The limits of our view fade off toward the edges, but we know that without turning the head, just moving the eyes, we can clearly take in some 100° from left to right and about half that top to bottom.

Except in very special circumstances we never look at images this way; wrapped around us. Instead, most people choose a distance that seems naturally comfortable — close enough to see well, but not so close that we have to keep looking from side to side. You can see this happening at any art gallery, or in the distance people choose to view a computer monitor, or hold a magazine with pictures. They may move closer to examine a detail, but this is usually temporary. On average, the preferred angle of view is in the region of 50°, and there is no coincidence that this is close to what is considered optically the normal angle of view (as in a standard lens for a camera). An easy experiment with a zoom lens is to keep both eyes open, one looking through the viewfinder, the other straight at the scene, and adjust the focal length until the two images — left eye and right eye — seem to match. The focal length will be around 45mm equivalent focal length (allowing for sensor size).

What is particularly important about this angle of view for HDR is that it affects our judgment of contrast. As we just saw, the eye and brain judge contrast much more locally than overall. Contrast in a small region of the scene is more important to us than contrast over our entire 100° (say) field.

Yet a picture usually occupies much less than this, and the net effect is that its overall contrast becomes more significant than it would if we were looking at the scene that was photographed.

Next, there is the clear boundary to an image, together with the fact that we know it is an object in its own right and is quite separate from the rest of the scene in front of us. In particular, we know that this is a photograph, and we expect certain qualities from it. There are certain photographic conventions, that I call the syntax of photography, which every viewer recognizes, accepts, and sometimes enjoys. These include, for example, silhouette, flare, the subtle handling of shadow detail, and bright highlights. For the most part, HDR software does not take this properly into account, and for this reason alone some post-production work is almost always needed after tonemapping. What is important is that photographs are definitely not expected to look like real-life scenes. Perhaps HDR, with its ability to reveal every detail from every zone of brightness, will change this over the course of time. Perhaps we will become accustomed to the strange "flatness" of over-detailed images in the future, but for now, the syntax of photography — the sense of how a photograph should look — absolutely must be taken into account.

A photograph has its own particular qualities that set it apart from paintings, drawings and other graphics. A number of these qualities are actually deficiencies, but over the course of time we have learned to put up with them, and even like them. One of these is indeed high contrast, to the point where the shadows are blocked up and/or the highlights are white and flared. Silhouettes are one clear example of lost shadow detail put to good graphic use, provided that the outline is recognizable or at least interesting. The dense shadows surrounding a spotlit subject are another example, serving to draw attention to the subject with visual drama. I'll return to these qualities in Chapter 3, HDR tonemapping, where they call for some consideration when tonemapping.

A comfortable field of view

My view as I write this, processed in a way to mimic the field of view. Our peripheral vision extends absolutely to 180º, but we are not normally aware of objects at the extremes unless they are moving. Over approximately 100º we have a reasonable awareness of shape and color. In this view (artificially represented here, as the field is greatly reduced on the page), the monitor occupies about 50º, which feels to be a comfortable field of view for an image.

Types of high-range scene

Scenes have high dynamic ranges for very particular reasons, and as it turns out there are a number of well-defined types of situation.

I'll make an attempt here to classify the types of scene. This is not an idle exercise at being neat, because the different reason for high dynamic range affect the way the images need to be processed during tonemapping. Moreover, knowing what kind of HDR scene you are faced with helps clarify decisions about dealing with it. HDR imaging is not appropriate for every scene, and while opinion plays a large part, it is important to decide if and when you are going to step from normal shooting to this much more involved technique. Note that the example photographs here are all low dynamic range. I don't want to beg the question by showing just now how tonemapping can treat them.

The critical question is how distinct and separated are the bright and dark areas in the image? There are a number of ways of referring to this,

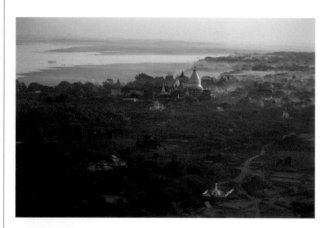

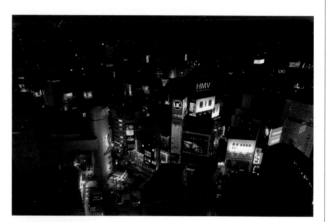

Continuous gradient
No edges on any significant scale, and no clearly defined regions. This kind of lighting situation, here an aerial view over Pagan, Burma, has the light source just out of view, illuminating a fairly consistent texture of subject. Presents few tonemapping problems.

Scattered bright lights
Typified by an overview of any modern city at night, in this case Shibuya, Tokyo. Segments are too small to present issues, and many of the smaller lights are visually perfectly acceptable even if clipped and white. The main job of tonemapping is to bring out shadow detail. Not a particularly difficult tonemapping task, but the results (see page 149) usually impress.

and I use the word *segmentation*. This goes back to early Gestalt theory (see page 26) and the idea of fields or frameworks — for the most part, areas that have common illumination. At the low extreme of segmentation, imagine a smooth gradient from very dark to very light, from one corner of the frame to the opposite. At the opposite extreme, imagine a very bright rectangle in the middle of a very dark background. Segmentation is important in HDR imaging because it calls for different ways of treating the different areas. In the case of extreme segmentation, it is perfectly obvious to the photographer that each segment needs its own treatment, but not necessarily so to the tonemapping software. And, as we'll see in Chapter 3, HDR tonemapping, the big issue is the sharp dividing line between segments, known as the luminosity edge. The HDR treatment within each segment may conflict with the massive and sharp change in brightness across segments.

The simplest kind of strong segmentation is when one quite large segment sits within another that is very much darker or lighter. In photography, this occurs as the classic example of HDR, an interior view looking out through

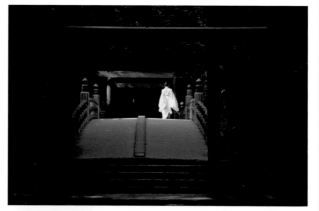

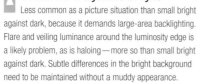

Small dark against bright

Less common as a picture situation than small bright against dark, because it demands large-area backlighting. Flare and veiling luminance around the luminosity edge is a likely problem, as is haloing — more so than small bright against dark. Subtle differences in the bright background need to be maintained without a muddy appearance.

Small bright against dark

A small, but significant region or segment of bright tones against an overall background. This is typical of any spotlighting effect, artificial or natural. Here it is created by a gap in the trees over the Japanese shrine at Isé, allowing the sunlight to illuminate just the center of the bridge. Holding the highlights, yet rendering them bright (even luminous) is the main issue for tonemapping, as it is for normal photography. However, judgment plays a critical role in a situation like this, because tonemapping can open up the shadows greatly. Yet this might destroy the point and attraction of the image — in my judgment it certainly would detract from this photograph.

a window to a sunlit exterior. This arrangement so strongly exemplifies HDR that it is often used as a test case, and indeed I use it later in the HDR Workflows chapter. When the two segments are large, both demand adequate treatment. When there is a greater difference in size, things change somewhat, because then there is more of an option to tolerate loss of detail in the smaller one. In other words, if there is a small bright window in the room, it is less important to the overall image, and can be allowed to flare more. The inverse of this kind of segmented image is dark against a bright background.

Few scenes in real life are this simple, however, and as the complexity increases, the layout of the image becomes more of a pattern. This assumes, of course, that the areas are still strongly segmented — that is, they have strong, distinct boundaries like a window frame or a sharp shadow edge in bright sunlight. The more of a pattern, the greater the need for equal treatment of bright and dark.

Weak segmentation is when the edges between bright and dark areas are not well defined. The areas may merge into each other with soft gradients,

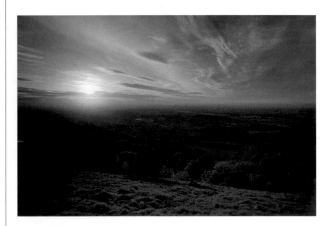

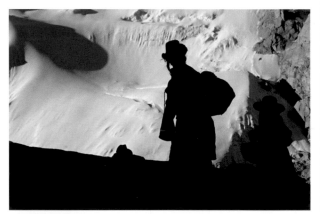

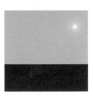

⬚ Divided frame

The classic situations for this condition are a landscape with horizon against a bright sky (and for this, cloudy rather than blue gives the highest contrast) and a roof-line against a sky. By far the main concern is haloing, on both sides of the strong luminosity edge. Certain tonemapping algorithms may additionally create unevenness of tone across the sky, and some settings, notably those that affect high-frequency, small-scale detail, may introduce a noisy texture into the sky.

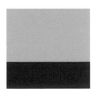

⬚ Large dark against bright

These are the conditions typically treated by photography as silhouettes, and for this reason such scenes present an issue of judgment. Strong tonemapping settings that open up shadow detail greatly may well look false (see pages 70-71). Haloing is definitely likely.

or there may be such a complex mixture that segments are not meaningful. Segments may be nested inside each other, or may intersect each other. Again, going back to Gestalt theory, the more complex an image, the more complex the reasons for a viewer to decide which areas "belong" together. Instead of grouping into segments by brightness alone (as with the classic view out through a window), the subject itself plays a greater part, and this is obviously a factor that HDR software cannot judge. One kind of weakly segmented scene is a smooth gradient from dark to light, for example if you were inside a dark, curving tunnel looking towards the entrance, but with the entrance itself out of sight. Another is when the contrast is between a background and a large number of points, as in a night-time view of a town or city from a distance, with many lights scattered over the scene.

▽ Pattern

A more or less equal arrangement of small-to-medium bright and dark arrangements. This is the classic lighting situation of chiaroscuro and depends on a bright sun (or other light source) casting a pattern of shadows. Dappled light filtered through leaves is one typical example, as is this street scene at midday in Barcelona. Haloing is a distinct possibility in tonemapping. Aggressive tonemapping will open up shadow details too much, so that they look false and even show signs of tone reversal.

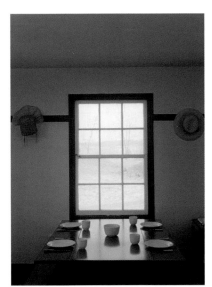

△ Large bright against dark

This is the classic "window looking out" scenario faced by all interior photographers and many others. There is an important psychological and perceptual component in deciding how to tonemap scenes like these—how important is it to see full detail outside? The interior normally has a given ideal—everything visible but possibly slightly dark—but decisions on the rendering of the bright area can vary. If it is a window, as in this example, we normally do want to see out, even if in photographs we are accustomed to not being able to see detail. However, a full rendering of all tones and colors outside to match those inside will always look unusual, and this has to be taken into account. Scenes like this are a major tonemapping problem, partly for the reasons just mentioned, but also because of technical difficulties. Haloing is likely to be severe, and most of the necessary steps to attenuate this also reduce the effectiveness of the tonemapping at keeping a full and realistic range of contrast within the bright area. Excess color saturation in the bright segment is also likely.

HDR terminology

In addition to standard definitions of image qualities, HDR imaging has created the need for new terms to describe qualities that until now could not be adjusted.

The qualities themselves might have existed or could have been detected in pictures, but didn't impinge much on the awareness of photographers. What has changed all this is the ability to alter them.

So now we need a new vocabulary for some of the things that can happen to images using this new software. Many of these are pure inventions, because the image qualities are themselves new, created (or at least adjusted) by complex algorithms. Sometimes these qualities are side effects, unexpected and unintentional, but possibly useful.

At this early stage, standard terms are already frequently misused and misunderstood, especially on internet forums. The possibilities for this getting much worse with HDR are ripe. A common situation arises: Here's an

▼ **Glow**
A luminous and sometimes self-luminous quality, usually due to a slight amount of soft flare around a bright area.

△ **Self-luminous**
A very bright area that appears to be lit from within, or is indeed a light source. This quality of emitting light, or appearing to, distinguishes it from reflected whites. One of the issues in treating highlights in HDR imaging is the definition of such "whiter than white" areas against white.

effect created by tonemapping, but what do we call it? Software developers invent terms — for example, Vibrance from Photoshop's CS3 raw converter, or Smoothing from Photomatix. Here, illustrated with examples, are the key terms used in this book, which are taken from various sources. Even though I explain some of them much later, I think it's a good idea to set them out here in one place, to avoid confusion. Elsewhere you'll see more or less the same qualities described with different words. No matter. I'm not trying to insist that these are "correct" but rather trying to establish as clearly as possible what we're talking about.

Halo
An edge artifact and one of the most common faults in tonemapping. It takes the form of a bright but softly graded border running around a well-defined edge. Here, the halo is evident in the sky around the roof and tree.

Local contrast
An increase of contrast within a part of an image, as opposed to the overall contrast of the entire image. Thus, local contrast is relative to its immediate neighborhood. The area across which this contrast is judged can be varied with some tonemapping operators. In this view of the Temple of Karnak in Luxor, Egypt, local contrast is that within the red and green rectangles, as opposed to contrast between sky and shade.

Specular
A very small, bright point, such as a reflection of the sun in a convex surface or a small, distant lamp. Because speculars are so small, it is generally accepted that they can be allowed to blow out to pure, clipped white. Here they are caused by sunlight on small drops of water.

Tone reversal

When adjacent darker and lighter tones are over-processed during tonemapping, so that they reverse their relationship. Typically, a shadow is lightened so much that it becomes brighter than its neighboring detail. The result looks artificial. Here, the more natural, less strongly processed section of an image is on the right. Aggressive tonemapping on the left has reversed the hierarchy of tones, in particular at the top of the arch, between the lit area directly above the lamp and the shadow extending outward.

Caustic

The complex pattern of light refracted through a transparent material acting as a lens (such as glass or water), forming overlapping curves, hot spots (hence the name), and often chromatic aberrations.

Photographic

The opposite of artificial, in that the image seems to have the qualities normally associated with photographs. These may include a small degree of clipped highlights and shadows and many of the deficiencies of low dynamic range images. Although a highly subjective quality that resists precise definition, it exists because most people are so accustomed to the way that traditional photographs look. Paradoxically, many tonemapping operations reduce this photographic appearance. Here, shadow, highlight and shallow depth of field are all hallmarks of a photograph, and even though they reduce the amount of information, they add hugely to the attractiveness of the image.

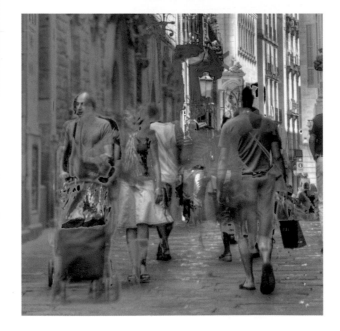

Ghosting

When a subject moves in the scene during the several exposures, combining them into a single HDR image creates overlapping and semi-transparent areas. There are software solutions at the time of generating the HDR image, but not always successful. In a multiple overlapping sequence such as the people in a street in Barcelona, full correction is impossible, and outlier artifacts are visible.

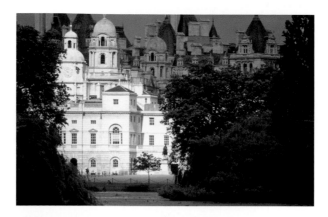

Segment

A distinct, bounded area within an image, usually but not always defined by its different overall brightness. The boundary edges (luminosity edges if they are defined purely by brightness) determine how strong is the segmentation. A strong effect risks halos during tonemapping.

Microcontrast and crispness

Local contrast enhancement at the finest scale, a few pixels only, almost but not quite as fine as sharpening. The overall appearance of such an image (in which small-scale detail has been heightened by intensifying microcontrast) is difficult to describe in a way that accurately distinguishes it from sharpening, but crisp is one such term. As such, crisp is a subjective definition. In this ceiling detail in Nebraska's State Capitol building, microcontrast has been applied to the right-hand version.

Artificial

An image condition in which the appearance of tones and colors departs from reality, normally because of incorrect or excessive tonemapping. Tone reversals, excess saturation, halos and exaggerated micro-contrast all contribute. This evening view of a tented camp in India displays full detail in all tones, many of them unexpected, but the overall effect, including the haloing, looks more like an illustration than a photograph.

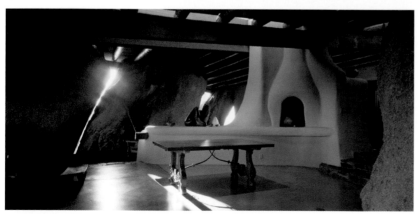

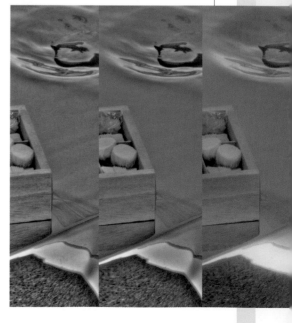

Flare

An extreme form of glow, also known as veiling luminance or bloom. A problem in HDR because the lighter exposures can collect flare information efficiently and this is preserved in the final HDR image.

Smoothing

A "softening" (without blurring) effect on fine detail including noise very much associated with tonemapping, and reminiscent of a median filter selectively applied. Excessive smoothing creates a "plastic" effect on surfaces. In this detail of a chrome steel surface the middle and right versions show the effects of increased smoothing.

HDR **capture & generation**

The software available for creating realistic photographic results from HDR data has only been available for a few years, but High Dynamic Range research goes back to the early 1990s. It received its main boost from the motion picture industry, where computer special effects were becoming important at around the same time. Nevertheless, for still photography this is a recent acquisition, not yet used universally. There is little doubt that HDR in some form or another will be used in digital cameras, but for the time being almost the only way of shooting a high dynamic range photograph is in a series of exposures. This is not particularly complex, though it does have its limitations, but it is primitive compared to what will happen in the future. Indeed, at the moment — in commercial terms — still photography is not as important a use of HDR as special effects film-making. In particular, it is essential for fitting CGI into live-action scenes, and early showcases for HDR include movies such as *The Matrix* and *Spiderman*.

This is a technical area for photography. Eventually much of its complexity will be hidden away under the hood, but for now it is quite important to know how and why the HDR process works. HDR imagery, new and potentially revolutionary, is where research into perception, mathematics, and photography all converge — like it or not. Most of the frustrations experienced by photographers in trying to use these techniques to solve contrast problems, and to achieve an image that they judge to be "right," occur through not understanding fully what tonemapping can and cannot do. Even if we accept that there are as many interpretations of an image as there are individuals, what do we have to do to get the image "right" for ourselves? Well, to borrow a phrase from the research literature, that is an "ill-posed question." The brutal answer is that there is no "right." Furthermore, the software tools are not yet perfectly honed to deliver predictable and perfect results.

HDR begins with capture, then moves on to generating an HDR file from the captured sequence, and these make the subject for this chapter. Until recently, many of the principles of digital photography were based on what the equipment could do rather than what the tones and colors of the scene needed. HDR changes this. In capturing a range of exposures you are making a full and complete visual record of the view in front of the camera, not fitting part of it into what the sensor and camera is capable of. This is a fundamentally different way of thinking about imaging. In part, it anticipates future developments, whatever they may be, that may be able to use this image information in different, better ways. In part also, it contains the idea of archiving, making an exact, full record of the scene in front of the camera. There is something quite attractive about this idea — that the world in front of the camera comes first, not the inadequacies of camera, film, and sensor. Also, if you have this information stored digitally, you may be able to revisit it for better, or more interesting, results at a later date.

Capture

Currently, the only camera capable of capturing a truly high dynamic range in one shot is the German-made SpheroCamHDR.

The SphereoCamHDR is a panoramic camera with a vertical resolution of 5,300 pixels, that scans the scene as it rotates. Its dynamic range is in excess of five orders of magnitude, or 26 f-stops. It has limitations, quite apart from the high cost. As the image is captured by scanning, line by line, it takes between 30 seconds and several minutes to complete a full 360° panorama, depending on the exposure time and lens fitted.

For now, direct capture is a long way off for consumer cameras, so the only practical method is a range of different exposures. For this to work successfully there needs to be little or no movement between frames, either of the camera or the subject. If there is significant movement, there is a risk of the final HDR image being blurry. As we'll see, the tolerances for movement are slightly relaxed now that most of the HDR software on the market has ways of dealing with shifts of a few or several pixels, but the ideal is still perfect registration between frames. The only thing that should change is the exposure.

Naturally, this limits the kind of subject matter that you can reasonably expect to shoot for an HDR result, although not as much as you might imagine. Static subjects such as landscapes, architecture, interiors, still-life, and close-up details are ideal. On page 50 we'll look at the techniques for handling some subject movement in the image, and after some experiments yourself you should be able to get an idea of how much relative movement can be tolerated. If you shoot the sequence quickly and the movement inside the frame is only slight, the software that generates the HDR file may be able to handle it.

In order to keep the frames identical in a sequence, lock the camera down whenever possible. Yes, handheld shooting is possible, but it always carries a risk of producing a blurred result — or a large amount of pre-production work trying to align the frames. For the most part, the assumption is that you will use a tripod, and take all the usual precautions as if you were shooting at

Shooting procedure

1 Frame view and lock down camera.

2 Set camera to manual exposure and set the aperture.

3 Guess shortest exposure needed to preserve highlights and shoot.

4 Check highlight clipping warning and histogram. Correct exposure is the longest at which there is no highlight clipping. Delete if wrong and alter shutter speed.

5 Once the shortest exposure has been captured, set the shutter speed two f-stops slower and shoot the second frame.

6 Continue changing the shutter speed by two f-stops and shooting until the darkest shadows are midtones. Check this on the histogram, the left edge of which should be in the middle of the graph.

Exposure sequence

1 Find the darkest exposure at which there is just some clipping of the highlights (shown here in red for clarity—the actual display on a Nikon is a flashing black).

2 Reduce the exposure a fraction of a stop until there is no clipping. Start shooting from here.

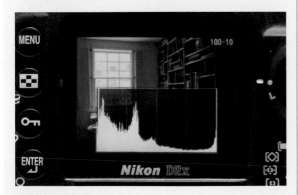

3 Increase the shutter speed by two stops and take a second shot. Increase a further two stops, watching the effect on the histogram.

4 Increase a further two stops.

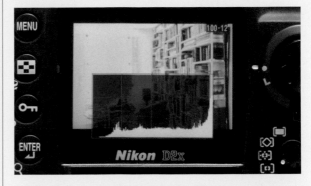

5 Increase a further two stops. Although much of the image is over-exposed, do not stop here, as shadows are still dark and potentially noisy.

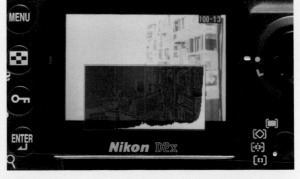

6 The left edge of the tonal range is in the center of the histogram scale, meaning that the darkest shadow is properly exposed. This is the last frame of the sequence.

A special technique for noise reduction

One problem with HDR shooting in dark situations, such as at night, is that the longest practical exposure (which depends on the specific circumstances) may still be short of ideal. This is particularly likely when there is movement. One possible solution is to take several individual exposures, all the same, instead of a much longer one. These can then be combined using a median procedure—the only variant will be the noise, so this is automatically filtered out.

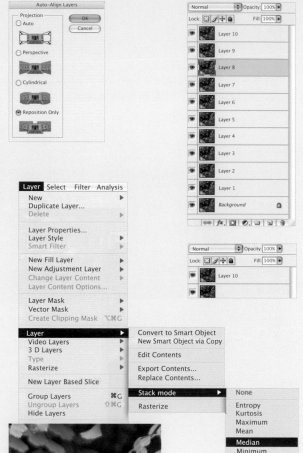

A shadow detail from this view of shaded plants shows visible noise. Eleven identical frames were shot rapidly, using the Continuous shutter setting.

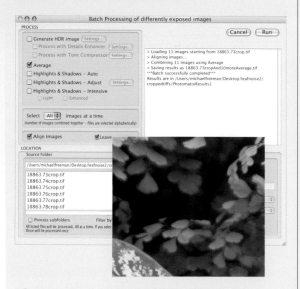

In Photomatix, these are combined in the Average method, which uses median filtering. The result? As if by magic, the noise disappears.

An equally effective but more lengthy procedure is Photoshop CS3's Stack Mode. After running Auto-Align on a layered stack, the layers are converted into a Smart Object, and finally this has a Median Stack Mode applied to it.

a long exposure (which in a sense you are, just that it is split up into a series).

The aim, and practice, of shooting a sequence of exposures is very simple, and there are just two decisions to make. One is the extent of the range, from how dark to how bright. The other is the spacing of the exposures, or how many stops between each. At one end of the sequence we need an exposure short enough to capture detail in the brightest parts, and at the other end an exposure long enough to fully capture all details in the shadows. In other words, we need to avoid clipping at both ends, highlights and shadows. Simple as this is, there are pitfalls, but usually these happen because of unfamiliarity and underestimating the range. At the highlight end, if there is a light source in view, such as the sun or a street lamp, the number of extra exposures needed, each one shorter than the one before, can be more than you might expect. And at the shadow end, a common mistake is to be satisfied with a bright exposure in which the shadow details are visible but still not fully exposed. Above all, it is much, much better to shoot Raw, because of the extra potential dynamic range and because the data is stored as linear luminance values, not processed in unpredictable ways by the camera manufacturer.

The best aids for getting the full range without wasting time and unnecessary extra exposures are the camera's highlight clipping warning, which typically flashes over the over-exposed highlights, and the histogram, which shows where the shadows fall in the tonal range. All good digital cameras now have these two display options, and frankly, anyone taking this amount of trouble to immerse themselves in HDR should be using a camera better specified than a cheap compact. Otherwise you would need to judge the end exposures by eye; the darkest exposure should show no obviously white areas, while the lightest exposure should show

Handheld capture

The essence is speed, to reduce ghosting from subject movement and to reduce the risk of misalignment from camera shake.

On a Nikon D2X the maximum exposure gap in Bracketing mode is only one stop, but the maximum range of nine exposures covers a reasonable range.

Next, maximum continuous speed is selected.

Vibration reduction is extremely valuable for this kind of shooting.

Scene-referred vs. device-referred

Until HDR arrived, image file formats such as TIFF and JPEG were all linked to the equipment. This means basically that the ways of encoding and storing images were created to suit the camera or the monitor, because these bits of hardware have special needs. This was all so obvious that it was hardly worth mentioning, but the technical term is "device-referred." The image information is made to suit the device. HDR, however, builds on a different premise. This is a more fundamental idea, that of recording and keeping all the information from the scene itself. Never mind whether or not it can be displayed properly, just concentrate on capturing the pure data of tones and colors.

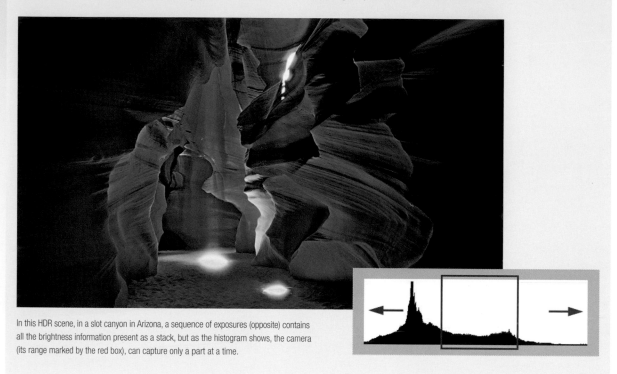

In this HDR scene, in a slot canyon in Arizona, a sequence of exposures (opposite) contains all the brightness information present as a stack, but as the histogram shows, the camera (its range marked by the red box), can capture only a part at a time.

nothing darker than a midtone. Additionally, the table on page 41 gives an indication of how many stops are needed for certain types of scene.

Next, the spacing between exposures. Practically, the answer is simple: two stops. This is the best safe compromise between having enough brightness information and a manageably low number of frames. There is nothing wrong with a one stop spacing, except that the extra images take up more storage space.

There are a number of ways of calculating and shooting the sequence, but I'm going to keep it simple and recommend just one, because it works reliably and quickly. All you need is a highlight clipping warning and a histogram display on the camera. The only control to change in the sequence is the shutter speed, not the aperture, because the latter affects depth of field and also

changes the shape and size of the lens diaphragm. Set the camera to manual and the aperture to whatever is appropriate for the scene.

Use the camera's highlight clipping warning to determine the shortest exposure in the sequence, and start with that. The ideal exposure is the one that just captures the brightest part of the scene — no clipping, but also no darker than this, to keep the number of frames to a minimum. Use whatever exposure measurement you prefer to estimate this, and shoot a test frame. Personally I find it quicker just to guess, then if the result is off, delete, change the shutter speed, and shoot again. With some experience, it's not difficult to get to within one or two stops on the first try, which means getting this end of the sequence right should take no longer than a few seconds.

For the second exposure, increase the shutter speed by two stops. Check this visually on the display or by the number of clicks. For example, I usually have my Nikon camera set to exposure increments of one third stop for regular shooting, so I simply count six clicks as I dial up the speed setting.

The third and subsequent shots follow the same procedure, increasing the shutter speed by two stops each time. The final decision is how far to continue. The point is exact — the exposure at which the darkest shadows appear as midtones. It's a common mistake to stop shooting short of this point, when the lighter parts of the image appear completely washed out. However, at this end of the sequence you are shooting only for the shadow details, so make sure that you continue until the histogram shows the far left edge in the middle of the display, as illustrated on page 41. You have now captured the full dynamic range of the scene.

Although I've taken pains to describe each step and decision, in practice this is a rapid process. The longest delay is in low light with the time exposures at the end of the sequence.

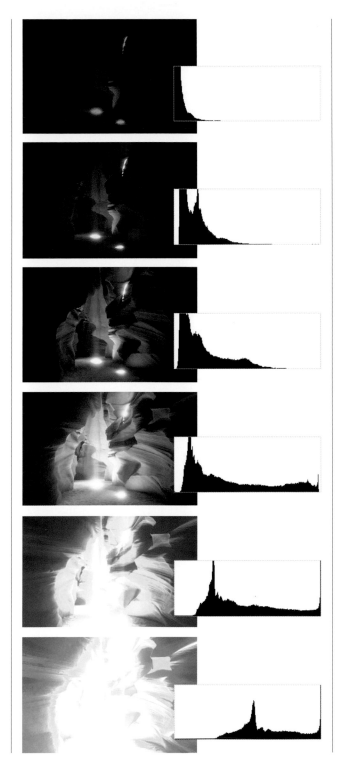

Generating the HDR

For the most part, creating an HDR image from the source LDR images is a straightforward user experience.

Almost everything is automatic in all the major HDR applications. Typically, you are asked to select the source images, and the program searches these for their EXIF data. From this it knows the exposure differences and can proceed with the calculations. If the EXIF data is missing (e.g., if the images have been pre-processed by a stitching application—see page 120), the application should be able to estimate the spacing, or at least ask the user to supply this information (easy enough to find from the original images). Photomatix is trouble-free in this respect, but Photosphere, for example—though excellent in other ways for HDR generation—will work only with the necessary EXIF data present. In this case, there is EXIF data editing software available for adding the information, but in practice this takes time and can be unreasonably difficult.

Photomatix

There are three routes in Photomatix for generating an HDR image. One is to open the LDR files first, and then Generate. A second, faster, and more efficient method is to go to *HDR > Generate*, which accesses a Browse... window, followed by Generate in the same dialogue window. If the software cannot read the exposure information in the EXIF data (such as with an old lens), a window appears giving options for either setting the exposure spacing or applying steps individually to each image. The third route, fastest of all if you have more than one HDR to create and have already placed the source LDR images in separate folders, is to go to *Automate > Batch Processing*.

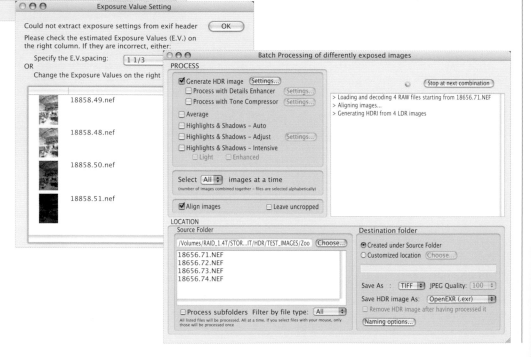

Depending on the software, there may be several options. One, offered in Photomatix, is the choice of calibrating the camera in order to recover the tonal response curve. While this sounds like something you ought to do, the Photomatix recommendation, which is quite right, is not to bother, but instead let the software apply a standard curve. The reason for this is that digital cameras rarely have a consistent response curve, unlike film. First, the response is linear, but then the camera pre-processes this Raw file to make it look acceptable to the eye with its firmware. How the firmware does this varies from camera to camera and is proprietary, unpublished information.

What is known, however, is that some camera firmware makes extra adjustments in attempts to correct for under- or overexposure. The net result is that the response curve can vary from shot to shot, which invalidates the whole idea of calibrating the camera. A standard curve is likely to be more accurate. In any case, if you are generating the HDR directly from Raw files, which I cannot recommend strongly enough, the issue is bypassed.

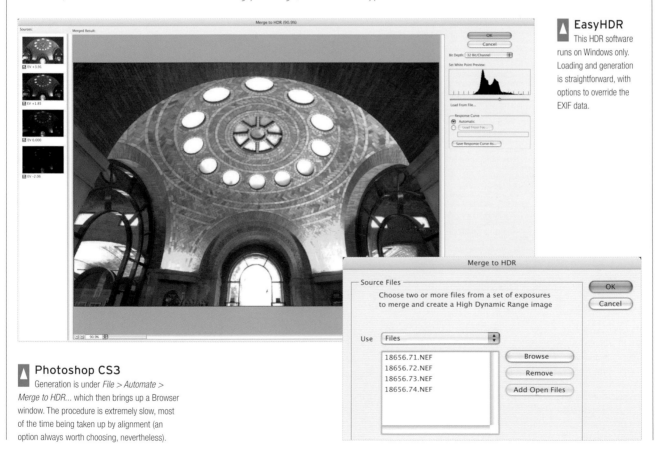

▲ EasyHDR
This HDR software runs on Windows only. Loading and generation is straightforward, with options to override the EXIF data.

▲ Photoshop CS3
Generation is under *File > Automate > Merge to HDR...* which then brings up a Browser window. The procedure is extremely slow, most of the time being taken up by alignment (an option always worth choosing, nevertheless).

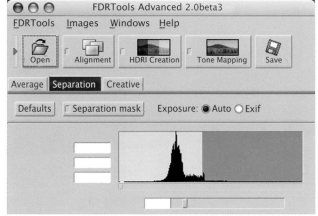

Raw files retain the original linear profile — a straight line, basically, and this needs no conversion.

Other options are alignment, ghost removal, and flare removal, which are dealt with in more detail on the following pages. Alignment means comparing the content of the image from frame to frame, then shifting one or more frames slightly to bring them all into register. It takes longer, but is a wise precaution and avoids a blurred end result. Ghost removal is worth attempting only when there has been subject movement between frames, and flare removal (not available in all HDR applications) attempts to reduce image flare that has been captured in the bright exposures.

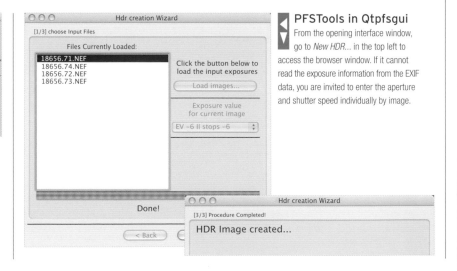

FDRTools

The special feature of this HDR software is that it merges the procedure of HDR generation with tonemapping, at the same time as offering more than the usual controls for fine-tuning the way in which the source images are combined. Usefully, this allows you to keep returning to the generation steps from tonemapping to make adjustments.

PFSTools in Qtpfsgui

From the opening interface window, go to *New HDR...* in the top left to access the browser window. If it cannot read the exposure information from the EXIF data, you are invited to enter the aperture and shutter speed individually by image.

The various procedures for generating HDRs in different applications are shown here, and also in the HDR workflows chapter's case studies. Note that there may be a choice between opening then generating, generating without opening, and batch processing. The more automated processes tend to be faster, and the differences in speed are considerable, as the table to the right shows. The same group of six TIFFs, each 10Mp (Megapixels) in size, took between 15 seconds (hdrgen and Photosphere) and 2 minutes 50 seconds (Photoshop) to turn into an HDR file.

Time difference

Times taken to generate an HDR file from 6 × 10Mp TIFFs, including alignment but not including opening the HDR.

Generating software	Time (seconds)
hdrgen	15
Photosphere	15
FDRTools	31
Photomatix batch	48
Photomatix Generate	58
Photoshop	170

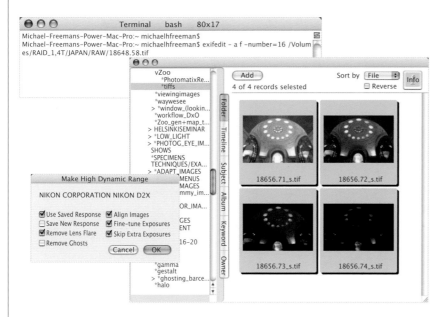

▶ Photosphere

This software, written by Greg Ward, one of the founders of HDR research, is both a browser and cataloging application that supports HDR files, and a generator. The interface is far from fancy, very basic indeed, but its functionality is impressive. While Photosphere performs no tonemapping of final images, it can generate HDR files fast and displays very clear previews (by means of a simple tonemapping operation on the fly). In particular, it has the option to attempt lens flare removal. This last function, unfortunately currently lacking in other HDR software, makes Photosphere a valuable program, even if used only occasionally.

One notable limitation when using Photosphere to make the HDRs is that it demands all the EXIF data, and if for any reason it cannot find the shutter speed and aperture (an old lens, for instance; a stitched file that has not carried through the data; or a scan from film), it will fail. The only solution here is to add the missing EXIF data before using Photosphere, and the options are limited. With an old lens, for example, the aperture information may be missing. This is hardly serious, as in shooting a sequence the aperture should not vary anyway. Nevertheless, some value has to be given. The EXIF editing here was done in a command line program, EXIFutils from Hugsan. The process is straightforward, but as always with command line instructions, one typing error and it fails—particularly easy to do when the image is buried deep within sub-folders.

▶ hdrgen

This is the software used by Photosphere, but accessed by command line. The disadvantage of command line operation is that it is very easy to make typing errors, resulting in false starts. Otherwise, it is precise and fast.

Alignment

Despite best efforts to keep the camera still between exposures, there is always a risk of a slight movement from frame to frame, even if only a pixel or two in amount.

Because this is likely, and yet may be difficult to spot when you open and look at the images, all HDR generating software offers the option to align the images, meaning running a variance test over them and bringing them into register if necessary. The default is usually alignment off, because it adds to the processing time, but it is strongly recommended.

The big programming issue with alignment is speed. This is a computationally expensive operation, so there are differences between HDR programs in how fast they are at aligning a set of LDR images. One technique used to speed things up, though hidden in the inner workings of the software, is first to make an image pyramid (successively smaller versions) out of a black-and-white bitmap. The alignment calculation is then performed on the smallest image, which is quick to do, then this shift transferred to the next largest version, adjusted, and the new shift passed on — and so on to the final full-size version.

Alignment does have a failure record, though usually small, so it's worth checking the final HDR result immediately at 100% magnification. If there is some blurring or ghosting, it may well be because of a rotational shift between frames, as this is the most difficult to correct. Alignment works best with simple *x* and *y* shifts. In any case, a major shift between frames may simply be too much for the software to compute. If there is alignment failure, it may be necessary to prepare the LDR source images in Photoshop so that they are already aligned. The old-fashioned way of doing this is to load the images into a layer stack, and then, one at a time, move the overlying image pixel by pixel until it is in register with the layer underneath. Setting the Opacity of the upper layer that you are moving to between 60% and 70% makes it easier to see how good the register is, and a final check is to reset the Opacity to 100% and rapidly click the visibility icon on and off.

In Photoshop CS3, alignment has been streamlined, using essentially similar algorithms to those used by HDR software. First, copy the different images into a layer stack, then in the Layers palette make sure all are selected. This done, go to *Edit > Auto-Align Layers...* and then choose Reposition Only.

FDRTools

This software uniquely offers fine control over alignment, and it is possible to adjust this at any stage during tonemapping. By default, without asking, FDRTools aligns images automatically, and in the Alignment window shows the offsets (if any) by pixel.

Pre-alignment in Photoshop

This should never normally be necessary, but if the sequence is seriously misaligned and beyond the range of HDR software to align automatically, consider this method, using Photoshop CS3's Auto-Align. It takes time, but it is powerful, and offers warping methods as well as the simpler Reposition (*x* and *y* axes only).

A sequence of 3 images of a station in Tokyo.

Copy and paste into a layers stack. For interest, compare two layers by setting the top one to Difference mode. Here the overall offset is obvious, as is the ghosting caused by passengers walking on the platform.

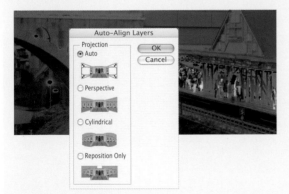

Auto-Align searches content in order to calculate and correct the offset. The result is displayed as Difference.

An alternative way of making a precise check is first to run Find Edges on the images.

Setting the top layer of two to Difference gives an even more detailed view of the variance.

The same image with Auto-Align applied.

Auto-Align running on the normal three images. The result can then be cropped and the individual layers copied back out to make three new files.

Ghosting

Because HDR images in photography currently have to be built from several frames, everything about these separate source images needs to be the same except for the exposure.

As we saw, there is some tolerance allowed by alignment procedures, but subject movement is a real problem. Alignment techniques take care of slight shifts between frames, but when the movement (or variance as it is called in imaging) is within the frame, different solutions are called for.

The answer lies in the fact that each individual frame has its own integrity, and this includes the frame in which the moving subject is optimally exposed. Naturally, there may be problems with the tonal range, and if the movement crosses a major brightness boundary this approach may not work at all. Nevertheless, the different HDR software applications use a number of ways to extract a reasonable result, eliminating all the exposures for this area except one. They detect the variance between frames and then favor one of them. The option, when available, appears at the stage of assembling the LDR source images in order to generate the HDR image.

And if this doesn't work well enough, which is often, you can always, at the cost of a lot more time, use the same principle manually. The idea is to select the best-exposed frame for the area of movement, copy and paste it into the

The Photomatix option for ghosting removal appears as soon as the source images are loaded. There are settings choices for this: Moving objects or Ripples (the latter intended for water surfaces), and a detection strength. The default works well in most cases.

The Photosphere option works off the browser window.

already tonemapped HDR, then erase all except this area. This frame may then need considerable LDR work, with the usual Photoshop tools such as Shadow/Highlight and Curves, to bring it close to a match in tone and color. Of course, the very purpose of HDR is to avoid this kind of tedious, manual work, but in special circumstances it may be worth it.

Ghosting removal works by favoring one of the source frames for the affected region, but this particular sequence is too much of a challenge for any automated procedure, as the moving subjects—the people walking toward the camera—are in different planes, each at variance with the other. Compare the version without ghost removal with three different software attempts at removal: Photomatix, Photosphere tonemapped in Photomatix, and FDRTools, which performs ghost removal by default.

Without ghost removal

Photomatix

FDRTools

Photosphere (tone mapped in Photomatix)

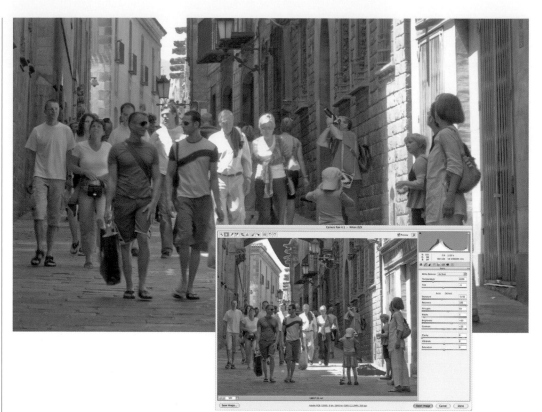

Following the same principle, but manually, with considerable effort, we can do the same thing successfully. The best-exposed frame for this region is opened and cropped in a Raw converter. Keeping the tonemapped TIFF open at the same time makes it possible to match them approximately for tonal contrast.

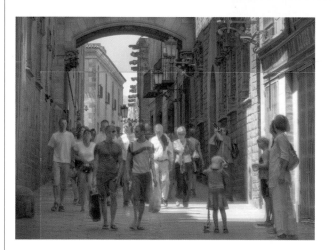

This crop is then pasted onto the tonemapped TIFF, and aligned for perfect register.

The crop, now the upper layer, is selectively erased with a soft brush for good blending.

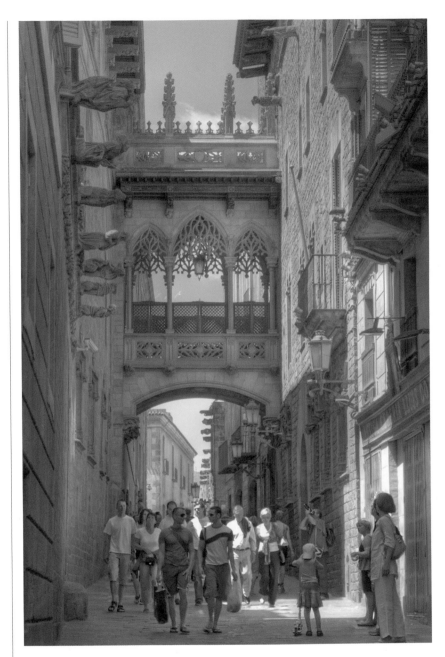

The result — good, but laborious.

An alternative approach is to reduce the number of frames to generate the HDR. Here, the original capture series took nine frames because the Nikon D2X allows a maximum one stop gap for bracketing. This is unnecessary, and reducing the series to just three key frames naturally makes ghost removal more successful.

The artifacting is not severe, and this makes regular retouching with the Clone tool a reasonable procedure.

Flare

Lens flare has a tendency to be exaggerated in HDR capture, and this transmits through to the tonemapping.

The basic reason is that camera and lens manufacturers still assume that images are being captured in low dynamic range (just two orders of magnitude), and this allows them to relax manufacturing standards in the optics. Some manufacturers work to higher specifications than others (Leitz, for example), but such things as the thickness of the aperture blades, the finish inside the lens to cut down internal reflections, lens surface coatings, and the optics themselves all affect flare. This is, as usual, at its worst in shots taken toward a light source, and as these are common in HDR photography, you can expect flare to be an issue every so often. A quick look at the lightest exposures in a sequence should be sufficient to tell you whether or not this will be a problem. A first precaution, naturally, is to use a lens shade and if necessary shield the lens with your hand or a flag.

Currently, Photosphere and the related hdrgen are the only retail software packages that offer a flare removal option. On the left of this series of three is a Photomatix-generated HDR of a lamp, tonemapped in Photomatix also. In the center is the same sequence generated in Photosphere without flare removal (and tonemapped identically in Photomatix), and even this shows a marked improvement. On the right, the same sequence generated in Photosphere with flare removal and given identical tonemapping, is a further improvement, although by just a little.

In this image, which we return to later, on pages 84-85, the diffused window at the edge of the frame is guaranteed to create flare.

Lens flare can be tackled during HDR generation, but currently — and rather disappointingly — most software does not implement this. Greg Ward's Photosphere (and its command line version hdrgen), however, does. In the examples here, it makes a significant difference. The technique that it uses is to try and estimate the amount by which a point source of light is spread over an area. Lens flare, as well as optical blurring, is traditionally measured by means of a point spread function, or PSF. This is a measure of the way the light falls off around a point of light — how far and how it fades. Usually this is radial (a circle of fading light) and the fading normally follows a Gaussian curve. Even though there may not be a point light source in the image, the program can usually make an estimate by searching for hot (white) pixels and looking for a threshold around them.

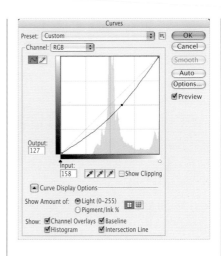

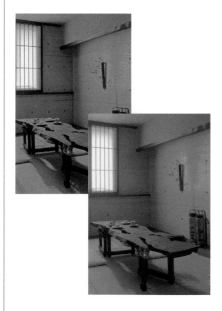

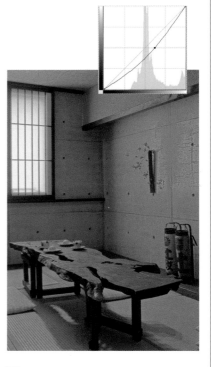

▲ A comparison between the best tonemapped versions from an HDR without flare removal (left, generated in Photomatix) and one with flare removal (right, in Photosphere), shows a major difference. Not only is there obvious flare around the window frame, but a veiled luminance extends across most of the image.

▲ Several stages of post-processing, described fully on pages 46-49, on the version without flare removal make a considerable improvement, but…

▲ …very little post-processing on the version with flare removal achieves a better result. This is simply a selection of the extreme left edge, feathered, and darkened with this contrast-strengthening curve.

Generators compared

There are, in fact, differences between HDR images generated, although trying to discover how and why for each image is a pointless task.

For interest rather than taking any action, some differences between HDR images are illustrated here. This is a very imperfect test, because in order to view and judge the results, they have to be tonemapped. In order to keep this consistent, I've used the Photomatix v2.5 default on an image that responds fairly well to this. The result is some way from being what I would want, but no post-production has been done in order to make the comparison a little more meaningful. Nevertheless, don't use this comparison to assess how much better or worse each one is. They are all fine as HDR files, just different. The general advice remains to use the HDR software that you choose for tonemapping to generate the HDR also, unless you need a special feature that is unavailable, such as flare removal (currently only in Photosphere and hdrgen).

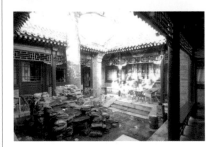

The same source sequence of three images, of an old hutong dwelling in Beijing, are here reproduced exactly as tonemapped in Photomatix, with identical settings. Apart from the HDR generated in PFSTools, which displays some strange artifacting and colors, none of the results could be considered better or worse, just different.

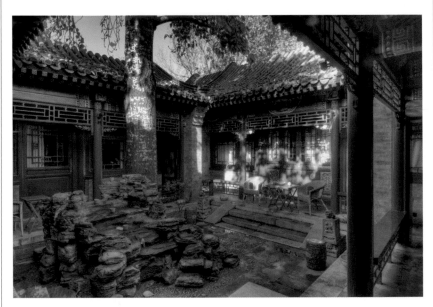

Generated in FDRTools

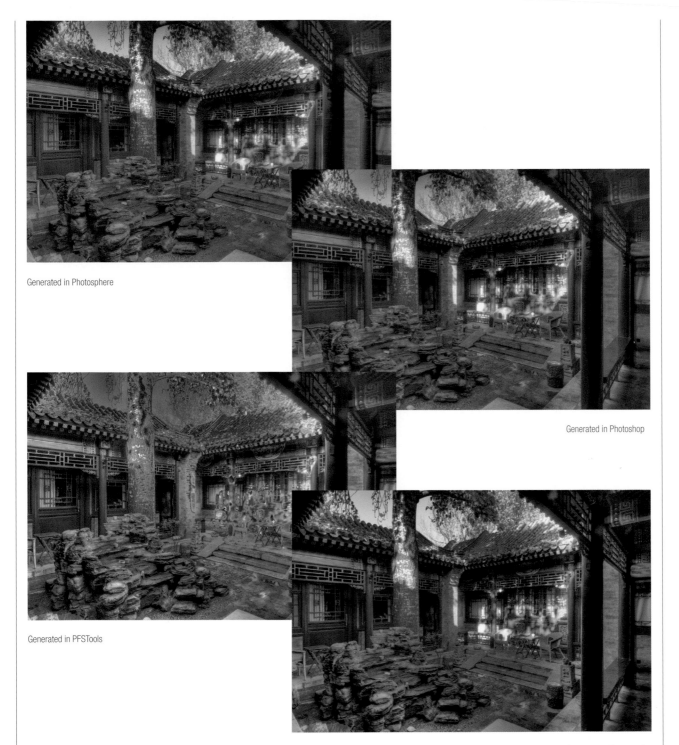

Generated in Photosphere

Generated in Photoshop

Generated in PFSTools

Generated in Photomatix

Encoding HDR

A high dynamic range scene such as a view from indoors out to a bright sunlit landscape covers five orders of magnitude (10^5 or 100,000:1), and as many as nine orders of magnitude if the sun itself is in view (10^9).

8-bit and 16-bit images are clearly not up to the task. 8 bits can cope with a dynamic range of little more than 10^2, and 16 bits less than 10^5. What is needed is more bits. 32 bits improves the situation greatly, making a dynamic range of more than nine orders of magnitude (10^9) possible.

Having many more bits is still only a part of the solution, because if the tonal values were to be assigned in the same old way, there would still be a limit. In a LDR, one of the unavoidable problems is noise and lack of detail in the shadows, and the main reason is the gamma encoding applied to the image to make it look right to the human eye. The eye does not see in a linear way (something twice as bright does not actually appear twice as bright); it responds to the

A gamma encoding does not hold enough information at the low end to allow exposure readjustment without introducing visible quantization artifacts. Another alternative closely related to the log encoding is a separate exponent and mantissa representation, better known as floating point.

cube root of the intensity of the light. Camera sensors, however, are linear. If you were to view a linearly encoded image, it would look far too dark, To compensate for this, a gamma curve is applied by the processing that happens in the camera.

One effect of this is to "stretch" the low bit values and compress the high values. This tends to create what are called quantization artifacts in the shadows, such as banding, and also enhances noise. So, while 16 bits per channel holds much more information than 8 bits, most of it is crowded into the highlights, where it is not needed, and little of it into the shadows. In this kind of encoding, there is no intermediate value between, say, 1 and 2. A very dark tone in the real world that should be, for example, 1.5, is forced to be either 1 or 2. The alternative, common to HDR formats, is to use the bits to express the tonal value more economically and much more precisely.

Format comparison

Format	Encoding	Bits/pixel	Dynamic range (orders of magnitude or 10ˣ)	Color accuracy (relative error)	File size (Mb/Mp)	Read/write speed (Mb/sec)
Radiance	RGBE	32	76 orders	1%	3	4.7/5.0
Radiance	XYZE	32	76 orders	1%	3	4.7/5.0
TIFF	IEEE RGB	96	76 orders	0.000003%	10	
TIFF	LogLuv32	24	38 orders	0.3%	2.4	3.3/4.0

The most common method is floating point, writing a value as a fractional number raised to a power of 10. An 8-bit channel is divided into 256 levels, a 16-bit channel into 65,536 levels, and a 32-bit channel, if handled this way, would have almost 4.3 billion levels. Writing this as 4.3×10^9 is not only more compact, but it can be made even more precise by adding digits after the decimal point. The ability to specify any tonal value across an almost infinite range, and do it with great precision, is the achievement of HDR formats.

There are a number of different formats, each with its own characteristics. In practice, your choice is likely to be controlled by the HDR software you use. The two most widely used and supported for photography are Radiance and OpenEXR. The qualities to consider when deciding which to use for saving HDR images are range, precision, file size, and speed of writing and reading. The size of the range, which is the main objective of HDR formats, is curiously unimportant, as all of the file formats cover much more than is needed in regular photography.

The first HDR format to be developed, and still the most widely-used standard, is Radiance, by Greg Ward. It comes in two flavors, RGBE and XYZE, the second replacing red, green, and blue with "imaginary" primary colors. In both cases, the bits are equally divided between a mantissa for each color and an exponent. As an HDR standard accepted by all software applications, Radiance is one of the two best choices for photography. Its dynamic range, however, is overkill, much larger than necessary, and this is at the expense of color precision, which although good is not excellent. The file sizes tend to be a little larger than ideal, although read and write speeds are fast.

The HDR version of the TIFF format also has its uses, not least because of its phenomenal accuracy, but tends to be used for temporary conversion within software applications. Its dynamic range is huge, even greater than

Advantages and disadvantages

Radiance RGBE and XYZE

Advantages	Disadvantages
Simple, open source	Large file size
Well supported by applications	Only moderate
Fast to read and write	accuracy
Compresses by average 20%	

Floating Point TIFF (IEE RGB 96-bit)

Advantages	Disadvantages
Most accurate	Huge file size
Largest dynamic range	

32-bit LogLuv TIFF

Advantages	Disadvantages
Good dynamic range	Poorly supported by
High accuracy	applications
Compresses by average 30%	

Open EXR

Advantages	Disadvantages
Good dynamic range	Slow to read and write
High accuracy	
Compresses very well	
by average 40%	

Radiance, and its precision exceptional — in Greg Ward's phrase, it is the "gold standard" of HDR — but these are well beyond the needs of photography. Moreover, its file sizes are more than three times those of Radiance, and they compress poorly. It is usually called Floating Point TIFF.

Another very high precision format is LogLuv from Silicon Graphics. This was also developed by Greg Ward, who here set about dealing with the shortcomings of Radiance (unnecessarily high dynamic range, precision that could be better). The idea was to keep everything just below the threshold of human perception, which is ideal for photography. As its name suggests, it uses a log encoding, which is used to compress a luminance channel, kept separate from a chrominance channel. LogLuv is very efficient, but has not been taken up by software developers as widely as hoped, due possibly to the fact that it does not use the standard color primaries (that is, RGB).

The practical competitor for Radiance as a storage option for photography is OpenEXR, developed by Lucasfilm's special effects company Industrial Light and Magic (ILM), and published as open source in 2002. At first glance it might seem to have lower specifications, as it uses only 16 bits (known as a 16 bit Half data type), but it has a number of advantages without compromising image information. The 16 bits are used as follows: one for sign (plus or minus), 5 for exponent, and 10 for mantissa. The result is a dynamic range that, while less than Radiance, is still more than adequate for photography,

Open EXR
Predictably, one of the examples Industrial Light and Magic give of their HDR format's flexibility features some well-known characters. For this and others check the site at www.openexr.com.

Which software supports which format

Photomatix	Photoshop	FDRTools	Easy HDR	qtpfsgui	Photosphere
Radiance RGBE	Radiance RGBE	Radiance RGBE	Radiance RGBE	Radiance RGBE	Radiance RGBE
Open EXR	Open EXR	Open EXR	Floating Point TIFF (IEEE RGB)	Open EXR	Open EXR

while its precision is much better. Specifically, it can cover more than 10 orders of magnitude, or 10^{10} (the full range of human vision is about 10^8 while just 10^4 in a single view), with a precision of 0.1%, ten times better than Radiance. Also, it can be compressed very well, not only with ZIP but with wavelet techniques (PIZ).

Comparisons performed by Greg Ward on all of these HDR formats show that OpenEXR and Radiance are the winners in precision, which for photography is the most important quality consideration, given that the dynamic range of all is more than adequate. These two are, indeed, the most widely supported in the software applications that you are likely to use.

▶ **Radiance rendering**
A computer-generated scene that was one of the earliest applications of HDR by Reuben McFarland and Scott Routen of the University of Indiana.

Color management

Color management works rather differently in HDR than with regular low dynamic range images—in some ways simpler, in other ways more complex.

It begins with the difference between a real-world HDR scene and the image displayed on a monitor. As is well known, the eye adapts easily and well to different brightness levels and even more so to differently colored light. The mechanisms are complex. As you might expect, the adaptation is different between looking at the real scene and looking at any representation of this on a display. In the first case, the light is coming from a number of different sources, such as the sun, reflections, and other lights. In the second, it is coming from a constant source within the monitor, or else a source striking a print.

So, for example, to take the familiar classic situation of a dim interior with a view through a window out to sunlight, in shifting the gaze from one to the other, the eye adapts, and in the course of doing this takes in a different color appearance. The same scene viewed as a single image, however, reveals everything all at once, and this can create a color mismatch.

Added to this is the way in which tonemapping handles colors at the extremes of the tonal range, in particular the highlights. In regular LDR photographs we are completely accustomed to seeing highlights blown out, so that even the near-highlights are desaturated. Restoring all this information, which is what HDR can do so well, brings back the saturation of colors in these high regions, which can be initially disconcerting. On top of everything, steep brightness gradients in an image tend to create oversaturation in HDR tonemapping.

These are the potential problems, but the good side to HDR imaging is that most tonemapping operators work on luminance rather than chrominance, and

▲ **HDR to the rescue**
Under typically unsatisfactory domestic lighting—small fluorescent strips with added tungsten and daylight—a normal LDR shot taken with a daylight white balance. This obviously needs correcting.

▲ **Color clipping**
The problem is the clipping of colors. All six swatches on the bottom row of the GretagMacbeth ColorChecker are neutral, from near-white to near-black, but clicking the gray dropper in Levels or Curves on each in turn produces wildly different results: from left to right on swatch 1 (white), swatch 4 (mid-gray), swatch 6 (black).

attempts to preserve the original ratios of red, blue, and green. HDR software is also capable of accessing the ICC color profile of the source images, although the procedure varies between applications. Photomatix, for instance, converts the images directly without converting them temporarily to another color space, which preserves the color space in the final HDR. The original ICC color profiles are embedded in the tonemapped HDR image. However, a special case with Photomatix is that this procedure works only when the HDR generation and tonemapping are done in a single session. If the HDR is saved, closed, and then opened later for tonemapping, the color profiles are not preserved. In this case, the color profiles need to be assigned.

For closer control over color, it always helps if you have the time to shoot a color target such as the GretagMacbeth ColorChecker, remembering to shoot it with the same sequence of exposures as the scene itself. Here, the procedure for color correction becomes more reliable than it is for LDR, because there is no risk of clipping primary colors that can skew the correction. In the tonemapped image, using a Gray Point dropper on one of the gray patches along the bottom is normally sufficient to bring all the colors into line.

 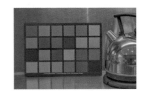

▲ HDR rendering
The same scene shot in a series of six frames each two stops apart and then generated into an HDR delivers a flat-looking rendering of the color target (because of the high dynamic range of the kettle and its reflections).

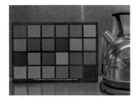 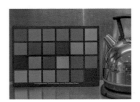 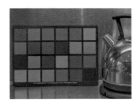

▲ Color fidelity
Performing the same gray point dropper operation on the same swatches delivers near-identical results, a sure indication of the color fidelity inherent in HDR.

▲ Oversaturated highlights
Excess color saturation in highlights is a common issue in HDR tonemapping. At the top is a detail of the main image tonemapped in Photoshop, using the best curve possible. In the center is the same image tonemapped with the Saturation Highlights slider moved to the left—a useful tool. The best possible version in Photoshop's Local Adaptatation method, at the bottom, is if anything more extreme than Photomatix's worst case.

Previewing

One of the peculiarities of tonemapping HDR images is that you cannot accurately see the effect until you have completed the processing.

There are ways of getting close, but one of the difficulties in showing a preview is that tonemapping is a heavy computation and takes time, while the other is that most of the TMOs use calculations based on size (and previews are usually much smaller than the final image). A common frustration is that, after spending time exercising fine judgment on the settings, the result is not what you saw in preview. For this reason, when the software offers a choice of preview size, select the largest.

There are two different kinds of preview used by HDR software. One attempts no compression, but may offer the choice of viewing a selected area of the range, and this is usually at the generation stage. The other is a limited attempt at showing a reasonable compression on a small version of the image. In Photomatix, the first of these options, at generation, works as follows: the full image is uncompressed, and therefore appears very contrasty and usually dark, but next to it is a small preview window that gives a 100% view of the area directly under the cursor. This optimizes the view in real time, so that moving the cursor across the image shows a constantly changing view that opens up shadow detail and reveals highlights respectively. The brightness of the full image preview can also be adjusted to a limited extent, in steps via the *HDR > Adjust View >* menu.

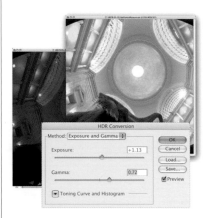

◭ Photoshop
Photoshop allows simple brightening on the main viewer window, and in the process of converting to 8-bit or 16-bit, an Exposure/Gamma pair of sliders (which are not much use for anything other than viewing).

◭ Photomatix
An overall view combined with a small, 100% preview linked to the cursor rollover.

◭ FDRTools
As Photomatix, FDRTools also features a 100% viewer, called Preview, to accompany the large Navigator window.

◭ OpenEXR
A full-size view only, but with exposure and Gamma sliders, made available by ILM, the creators of the .exr format.

In Photoshop, the equivalent display occurs during the HDR generation at the point when the source images have been selected and their exposure differences calculated, just before saving the image as an HDR file. The preview can be adjusted by moving the White Point Preview slider under the histogram. This sets the white point to wherever you like; moving it to the left clips part of the image but reveals more shadow details. Using this slider affects only the preview, which is embedded into the HDR file (but should you exit the HDR process by saving the image as an 8-bit or 16-bit image, unlikely though this may be, the saved file will preserve these preview changes). A similar slider is available underneath the saved HDR file, and is useful for examining different parts of the tonal range that you may want to work on.

The second kind of preview appears when HDR files are opened and in the tonemapping dialogue window. Typically, the preview is generated by the software by applying a preset tonemapping to a small version of the image. In Photomatix this appears in the tonemapping dialogue window, with a choice of sizes (the largest will be closest to the final result because of the size issues just mentioned, but also the slowest to refresh), and responds to most of the settings when they are adjusted. A 100% preview of a cropped area is available for examining such things as Microcontrast adjustments, but as the on-screen warning says, this will not show the final overall brightness result. That needs full processing. The preview opens by default, but clicking the Show Original button replaces this with the uncompressed HDR view.

In Photoshop, the preview appears at the point of changing the Mode from 32-bit to 8-bit or 16-bit, or alternatively, by going to *View > 32-bit Preview Options*. This offers two limited options for viewing, which are in fact the same as the first two global tonemapping operators in Photoshop's tonemapping processes (see pages 69-77). The first is a basic Exposure slider paired with a Gamma slider, to adjust brightness and contrast, and the second is a no-adjustment Highlight Compression. As with any preview in HDR, do not expect too much from them; they are there to give a rough idea only.

Many browsers and image databases fail to preview HDR files, although this will surely be addressed as HDR becomes more popular. Worth mentioning here is Photosphere, the no-frills browser and HDR generator (shown in top left of this page). Despite its lack of any interface design, it is extremely quick and efficient, and a very good way of previewing groups of HDR images. It uses a fast tonemapping operator, which can optionally simulate human visual sensitivity.

▲ **Photosphere**
The browser in Photosphere is one of the few that displays HDR files, with a choice of thumbnail size, also a large preview and associated information.

▲ **PFSTools**
A fixed-size viewing window in qtpfsgui, but it allows zooming out, also a selection of which part of the range to view (with a useful slider over the histogram at the top), and several pre-set viewing options that include linear.

HDR **tonemapping**

Computed tonemapping is relatively new, more or less within the last decade, and only more recently has software aimed at realistic photographic results become available. As a consequence, there will certainly be many improvements to come. Software available to photographers today is largely based on the work of a handful of researchers, and their original aims were not necessarily those of making good-looking photographs. The declared goal for most of these pioneers was, in the words of one researcher, Kate Devlin, "the creation of images that provoke the same responses that a viewer would have to a real scene." As we've seen this probably needs adapting to take into account the extra layers of perception involved in looking at images of scenes rather than just scenes.

Most of the interest in HDR, as well as the difficulties, lies in the tonemapping part of the procedure. Provided you have created an HDR image from a sufficiently wide range of exposures, properly spaced, you effectively have a complete record of all the brightness levels in the original scene. How to take all of that information and fit it into a photograph is the task of tonemapping.

Mastering this is less a matter of tips and tricks than of knowing what result you are trying to achieve. The software tools allow you to squeeze a huge amount of data into the limited capacity of a print or a screen view, but there is no one single result that will please everyone. The only way is to have a good understanding of how and why these tonemapping operators (TMOs) work, backed up by knowledge of their shortcomings.

The essential problem for all TMOs is how to define each area within which to make changes. You or I could probably do this in an instant, by pointing at what we see. Unfortunately, this seemingly simple act involves many layers of perception, evaluation and opinion. The TMO has to do this without comprehending the picture. Most TMOs look at each pixel's neighbors, and from this information can take tonal action, such as adjusting its brightness relative to these neighbors. One way to do this is to blur the area (blurring averages the brightness) and then use this information. The blur is not applied to the image, just used in the calculations. A problem is that, if the blur crosses over a sharp boundary such as a bird against the sky, it will create a visible problem, most commonly a halo, and while a very wide halo (across, say, a third of the sky) may be almost unnoticeable, a smaller one looks like what it is — an artifact.

The ideal is to keep these local-contrast adjustments neatly and exactly contained, but without a guiding human eye this is not easy. Most TMOs now employ some means of detecting strong boundaries — luminosity edges as they are known — but the computation is neither simple nor reliable. The basic issue, which will come as no surprise to any photographer, is the complexity of many, perhaps most, photographs. Imaging science is still a very long way from being able to analyze photographs comprehensively, and nowhere near being able to predict what importance a human viewer will attach to the different parts of an image. This, of course, is precisely what successful tonemapping needs.

Tonemapping theory

The critical issue with HDR is how to take all the brightness information in the dynamic range of a real-world scene and compress it so that is can be seen on a monitor and in print.

If there were a convenient and inexpensive way of displaying the full brightness range, none of this would be necessary, but currently the only display device is the large and costly Brightside monitor. And, as already noted, a paper print will probably always be the most wanted form of a photograph.

This part of the operation aims to compress an HDR image into a Low Dynamic Range (LDR) image. Simply compressing the HDR equally to fit the much smaller scale — in other words, in a linear way — is completely unsatisfactory. All the information is there, but the appearance is too dark and lacks visible detail in the dark areas. The basic issue is indeed visual appearance, and it's clear that in order to be successful, any way of compressing the HDR has to consider the way we see. This is, as we saw in Chapter 1, HDR scenes and vision, a complex matter. The software algorithms developed to do this job are accordingly complex, and are known as tonemapping operators (TMOs).

Three scales of contrast

While there is no clear-cut dividing line, practically speaking there exists contrast at a large scale (here illustrated by a high-radius blurring of this image), medium scale (as in the shapes of the lotus leaves against the reflections in the water), and fine scale (as in the detail of blades of grass). Tonemapping operators can work on all of these to varying degrees, depending on their design.

The problem of content

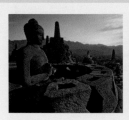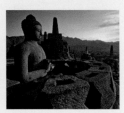

As discussed earlier, under Gestalt and perception, the powerful performance of HDR tonemapping operators at manipulating contrast locally is not yet matched by an ability to take into account the subject matter. This scene of a Buddha statue at the summit of Borobudur, in Java, illustrates the point. As shot (this is an LDR image), and in black-and-white for the purposes of this exercise to remove distractions, the eye is drawn to the Buddha statue because we know what it is, even though its tonal values and contrast are similar to those of the other stones. A blocky view of the image prevents us from recognizing the content—an analogy with the way tonemapping software "sees" the image. The selective contrast enhancement of the final image (the color version) is what we would do, but not what a TMO would do.

The major tonemapping issues

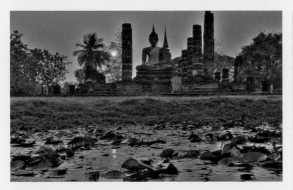

Halos

Because local operators adjust contrast in relation to local surroundings, there can be problems at strong luminosity edges—the sharp boundaries between distinctly bright and distinctly dark areas. Typically, close to one of these edges the operator includes the other side of the boundary in its calculations, and increases contrast across the edge. The result is a halo, a zone next to the edge in which dark areas go darker and light areas go lighter. See pages 100-103 for ways of dealing with this.

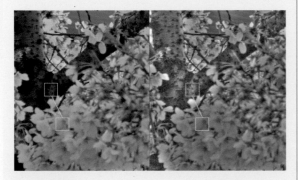

Tone reversals

These occur when adjacent tones cross one another, so that the darker of the two becomes the lighter. In any scene and image there is an overall hierarchy of tones, which of course the histogram displays the most flexible method and probably the one that is of most use to photographers. Unlike the other three methods, this one changes how much it brightens or darkens regions on a per-pixel basis (similar to local contrast enhancement). In contrast to the other three conversion methods, the local adaptation method does not necessarily retain the overall hierarchy of tones. It translates pixel intensities not just with a single tonal curve, but instead also based on the surrounding pixel values. This means that unlike using a tonal curve, tones on the histogram are not just stretched and compressed, but may instead cross positions. Visually, this would mean that some part of the subject matter which was initially darker than some other part could later acquire the same brightness or

become lighter than that other part. The distance that distinguishes between local and global contrast is set using the radius value. Radius and threshold are similar to the settings for an unsharp mask used for local contrast enhancement. A high threshold improves local contrast, but also risks inducing halo artifacts, whereas too low a radius can make the image appear washed out. For any given image, it is recommended to adjust each of these to see their effect, since their ideal combination varies depending on image content.

Ghosting

We saw this already on pages 52-55. Objects moving within the image appear in different positions in each frame of the shot sequence.

Noise and dirty textures

When the tonemapping settings are adjusted to maximize fine-scale detail, they also tend to exaggerate the appearance of noise and any other small artifacts. Large areas that are meant to be smooth, such as the sky, are particularly vulnerable. The problem can usually be taken care of by using the tonemapping controls carefully, reducing those that tend to enhance small details and applying smoothing sliders where they are available. In the example here, three versions of a detail of a stained glass window illustrate how HDR improves noise by taking information from the best-exposed tones in each of the source images. At left is the tonemapped image from an HDR generated from the two darkest frames; center from 3 frames; and right from all 4. The tonemapping operator is forced to use whatever material it is presented with.

Lens flare

Already dealt with on page 56, this tends to be exaggerated in appearance with an HDR image. This is best tackled at the generation stage, although currently most HDR software does not attempt this.

Tonemapping operators

All the software currently available for processing HDR photographs, aimed fully at photographers, is evolved from a handful of well-known research projects.

Beginning in the 1990s, researchers at mainly American universities developed a variety of ways of compressing the huge range of real-world brightness into a viewable form. The pioneers included Greg Ward, Paul Debevic, Erik Reinhard, Raanan Fattal, and others. This being academic research, the goals are sometimes entirely experimental and not necessarily to do with what photographers might consider important.

Tonemapping is complicated already, certainly enough to merit this entire book to explain it, and you might wonder why I would want to introduce the extra complication of the academic research that underpins it. I've had to read it, but why should you? Well, it rather depends on how comfortable you are working with new computer software that operates on new principles.

Some people are happy to drive a car without knowing how the engine and brakes work. Others find the extra knowledge helpful. The same applies here. In the following pages I attempt different levels of explanation of the user controls, from simple suggested settings to more involved discussions about the actual processes taking place. Certainly I stop short of the math. One of the problems in explaining tonemapping is that some of the processes are conceptually quite difficult. At least one user slider in a well-known consumer software produces an effect that surprised the developers and still resists mathematical explanation. You might well say, "I don't need to know that." But you might find it helpful to have a basic grasp of the kind of things going on under the bonnet.

The pioneering tonemapping operators, or TMOs, are well documented. Reinhard, Ward, et al's book *High Dynamic Range Imaging* is the classic account, and its accompanying CD-ROM contains the source code for about 20 of them. Indeed, the seven best-known operators, by Ashkimin, Durand, Fattal, Pattanaik and Reinhard are compiled and readily available for anyone to experiment with in PFSTools, which you can use free in the framework Qtpfsgui (see page 48). There is, however, a considerable practical difference between this research software and the consumer-oriented software that most of us use. Their aims are more academic, and they generally lack the tools designed to get the results as close as possible to a "natural" photographic appearance.

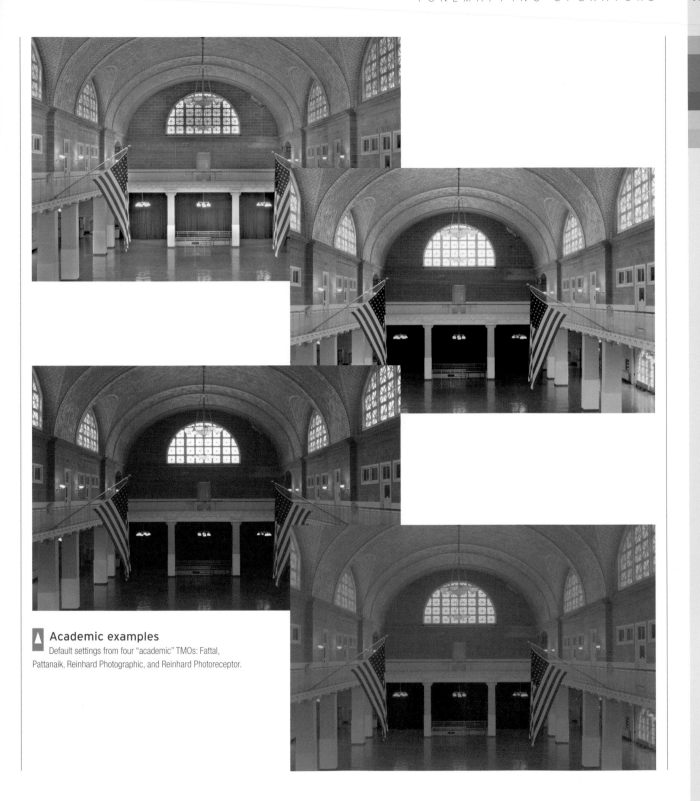

▲ **Academic examples**
Default settings from four "academic" TMOs: Fattal,
Pattanaik, Reinhard Photographic, and Reinhard Photoreceptor.

Nevertheless, the inspirations for some of these TMOs are fascinating. It was realized quite early that the fundamental issue is the difference between luminance and reflectance. As we saw on page 13, the range of reflected brightness is quite small, while the range created by light falling on a scene can be very high. If the compression could be applied to just the luminance, then the details due to reflectance could in theory be preserved.

A grail in tonemapping is how to separate luminance and reflectance in a scene. On the face of it, this seems an impossible task when you are presented with just an image, and don't have the light measurements from the scene itself. Well, as it turns out, it is not completely impossible. An early discovery was that in the majority of high-contrast scenes, the small-scale differences in contrast are to do with reflectance. For example, on the small table just in front of me (as I'm writing this on an aircraft), the difference in brightness between the almonds and the peanuts is because they reflect the light differently. But it is the same light on both of them. On a larger scale, however, the contrast tends to be because of the light falling on the scene. My neighbor has his window closed, while I have my light switched on, and there's a much larger difference in contrast as I look over there and then down here than between the two piles of nuts. This realization became one practical way of dealing with tonemapping: large-scale across the image treated as luminance, small-scale as reflectance. What this means is that one useful route to naturalness is to compress the large-scale contrast while holding or even boosting the small-scale contrast. This is the idea behind frequency domain operators and gradient domain operators, which I'll discuss in more detail later. Of course, this being a round-about way of approaching the difference between light falling and light reflected, it doesn't always work. It depends on the situation.

That this makes a photograph look more natural is reinforced by some of the work that went into the psychology and physiology of perception (not at all easy to separate the two). One generally-held theory is that human vision distinguishes local detail (that is, on a small scale, across a small angle of view) in a steady gaze, but senses large-scale changes in contrast in a different way, by shifting the gaze across the scene. An extension of this idea is that we somehow identify local areas — neighborhoods, frameworks, segments of the wider scene — and judge contrast within these.

Another approach, taken by Pattanaik et al., aimed at nothing less than mimicking the entire known HVS. A tall order, particularly as it sought to take

into account light-to-dark adaptation, with rods taking over from cones in the retina to give a better perception of brightness in dark situations at the expense of color information. The resulting TMO is very interesting, valuable, and quite useless for the purposes of producing an acceptable photograph.

Erik Reinhard et al., started from the other direction, taking his inspiration from Ansel Adams and his Zone System. As Reinhard noted, "The problem of mapping a range of world luminances to a smaller range of display luminances is not a new problem. Tone reproduction has existed in conventional photography since photography was invented," going on to compare the Zone System and the way his team's TMO works. "First, a linear scaling is applied to the image, which is analagous to setting exposure in a camera. Then, contrast may be locally adjusted using a computational model akin to photographic dodging and burning." Whereas Pattanaik wanted to model the workings of the eye and brain, Reinhard aimed for an end-result that had an accepted pedigree. He noted that "In traditional dodging and burning, the area that receives a different exposure from the remainder of the print is bounded by sharp contrasts. This is a key observation that should be reproduced by any automatic dodge-and-burn algorithm."

The results of all this interesting work were four kinds of TMO. The simple division of TMOs is between global and local operators, but in fact it goes further than that. A global operator, and this type was the first, is relatively uncomplicated. It works on all the pixels in an image in more or less the same way. Think of a typical S-curve in normal Photoshop editing; it increases contrast by brightening the lighter tones while darkening the shadows, smoothly and without changing the end points. That is one kind of global operator, illustrated under "Contrast and Gamma" on pages 20-21. You can push and pull different values, but it all happens across the board in a similar way. There are some very sophisticated global operators, and they produce results that are almost always "photographic" and familiar-looking, but they have a built-in limit. They are good with moderately high dynamic range images, but not so much when the contrast is very high.

Local operators are quite different in effect and in the way they work, and in concept much better able to handle extreme contrast. The idea is that for every pixel, the program searches around it and looks at its neighboring pixels, then lightens or darkens it relatively. In other words, what happens to, say, a mid-gray pixel in a bright neighborhood will be different from what happens to the same pixel located in a dark neighborhood. The key here is

Ansel Adam's Zone System in use. The image above is described in terms of zones using the zone chart. Adams preferred to use 10 zones, but using 9 (as here) or eleven makes it possible to have a midtone zone.

the radius that the program searches. The smallest neighborhood is a box of 9 pixels — three on each side surrounding the pixel in question. This kind of operation then has to be applied to every pixel in the image, which is computationally very expensive. It takes a lot of processing power, or else some very clever behind-the-scenes work in the calculations. In summary, local operators need first to decide how large an area around each pixel to use, next how to use these values to adjust that of the center pixel, and third, how to tie all these calculations together across the entire image.

You will often see TMOs divided just this simply into global or local, but the reality is less distinct. It is possible, for instance, to use both. In a sense, anyway, a local operator is working within a global (whole image) context. But beyond global and local there are two very different ways of approaching the problem, both related. I already mentioned the challenge of separating luminance from reflectance — the light falling on a scene, that can vary massively, from the light reflected from surfaces, that varies much less. The first way to make use of this was a frequency domain operator. Mathematically, images can be encoded by their frequency, rather like sound. Low frequencies are the large-scale contrast, high frequencies the small ones — details, in other words. Working in the frequency domain makes it possible to smooth out the big differences in low frequencies while separately preserving or enhancing the high-frequency details. In this way, they actually work globally and locally at the same time

Related to this are gradient domain operators. Low frequency, big changes across the image, normally related to the light falling on the scene, tend to have long gentle gradient slopes from dark to light. However, the high-frequency changes at a detail level, jump much more steeply across a small distance within the image. So, the contrast gradient can also be used to distinguish between large-scale and local contrast. The importance of these gradient domain operators, as they are called, is that they are heavily used in the commercial HDR software that most of us use.

Practical HDR software

As I mentioned, all the software that you're likely to use is ultimately inspired by this openly published research. Not, however, directly copied. Rather as we (I hope) don't take any pleasure in copying other people's photographs, developers don't like to simply copy source code. As Andreas Schömann, of FDRTools, puts it, "Algorithms as published from the research groups

of universities are more like templates. They provide ideas. If you give a research paper to ten developers asking them to implement the algorithm you will get ten different implementations." As this is a new area of imaging there is constant development, with both new software applications being launched and existing applications improving. There is a great amount of work going on behind the scenes, and as most of it now is proprietary, don't expect it to be explained in great detail by the developers. In fact, direct comparisons of user controls between different applications is pointless as there are many different routes towards achieving roughly the same goals.

At the time of writing, the practical software choices are few, even though there are more than 20 tonemapping operators in existence. The reasons for this are precision, the number of tools offered, platform and support for such detailed issues as Raw format and the absence of EXIF headers. At the top of the usefulness list is Photomatix, in existence since 2003 and under constant improvement. Next is Photoshops CS2 and CS3, FDRTools, Artizen and EasyHDR, each in its way good but variously less well specified than Photomatix. Platform is clearly of major importance, and as in any other area of imaging, cross-platform applications deserve to be taken more seriously.

None of this software is expensive, apart from Photoshop (but then HDR is a tiny part of its capability), but ultimately the question is which to choose for most of the work. It takes a long time to become familiar with any one application, and if you are going to use HDR regularly you will definitely want to streamline the workflow. HDR can be very time-consuming, and if you use it in a professional production environment, hours of computer work become costly. Each of the applications has a different philosophy, if we can grace it with this term. Photomatix aims for the best visual results by offering a large number of user controls that take time to get used to, Photoshop offers little to no support, with a disappointing lack of evolution from CS2 to CS3, but an intuitive curve-based control. FDRTools intends to stay simple and direct. Each of these appeals to different users.

A word about generating the HDR files. This is a straightforward matter from the user's point of view, so in theory you can tonemap HDR images created in a different application. Nevertheless, the files are not the same, and the results will be different, although the complexities makes it fruitless to detail the differences. As a general rule, it is wise to use one application both to generate and tonemap images. The tonemapping guidance given by the software is, after all, optimized for the HDR files that it has just created.

Four types of TMO

Global operators
Tonemapping processes are applied to every pixel in the same way. Pixels with the same original value get the same treatment. By way of analogy, applying an S-curve in Photoshop to an image in Curves so as to heighten the contrast is a global operation, although much simpler than a tonemapping operation.

Local operators
Local operators do what their name suggests. They take account of the pixels surrounding each pixel that they work on. The most common and quick-to-calculate local area is a 3 by 3 pixel block. This makes it possible to adjust contrast selectively by location within the image.

Frequency domain operators
These operators work by converting the image data into frequencies, and then apply different adjustments to the low frequencies that are more likely to be associated with illumination from the high frequencies that are associated with detail.

Gradient domain operators
Similar to frequency domain operators, these analyze the contrast gradients, then apply different adjustments according to whether the contrast slope is long across the image or short and sharp in local detail.

Photomatix

Photomatix from HDRSoft is currently the most mature and controllable software, not least because it is the oldest consumer tool and its developers have learned from user feedback.

The entire software package, which can be used as a standalone or as a plug-in for Photoshop, offers a variety of ways of combining a range of exposures, including several non-HDR methods. Within the HDR part, there is a basic choice between a global operator called Tone Compressor and a local operator called Details Enhancer. The Tone Compressor, as you might

The Photomatix tonemapping controls

Strength
Usually the first slider to check for adjustments. It controls the overall strength of the entire tonemapping process. Full strength is with the slider set to the far right. The default value set by Photomatix is 70 on a scale from 1 to 100—somewhat high, but chosen for naturalness. Moving to the left lightens the image overall and reduces any halos that may be present, with a tendency to look more artificial with many images. Moving to the right darkens, but may look more natural.

Color Saturation
Moving the slider to the right increases the saturation in the RGB channels equally. Moving it left desaturates the image. Note that the saturation seen in the preview window may be less than it will be in the final processed image. The default is 46 on a scale from 0 to 100.

Light Smoothing
Available in five settings only, due to the way the computations work. Affects the way in which the light is smoothed out across the image, with different distributions of halos. The radio buttons toward the left give an increasingly artificial look with well-defined halos around distinct edges. The two most realistic settings are those on the right, which also tend to be slightly darker. The exact effect depends on the image. This control vies for attention as the first adjustment to make with Strength, not least because there are so few choices—for most images between the two right-hand settings. If the image shows halos on the default settings, try choosing the far right (highest) setting.

Luminosity
This slider adjusts the overall brightness and contrast of the image. The scale is arbitrary from -10 on the left to +10 on the right, default zero. Moving the slider to the right opens up shadow detail (specifically expands shadow and mid-tones) and also brightens the image. Moving the slider to the left darkens and lowers contrast in the shadows (specifically, compresses shadow and mid-tones). At extreme right settings, noise is enhanced (see Microsmoothing to counter this).

Because the Gamma slider in the Tones sub-menu also adjusts brightness, though with less compression of shadow and mid-tones, the two can be used together to control overall contrast (see page 82 Luminosity vs. Gamma).

Tone sub-menu
Offers three traditional brightness and contrast controls. Under most circumstances, these should not need to be used. As with the three other sub-menus, these are advanced controls, for refinements to the basic tonemapping.

White Point
This slider sets the point beyond which outlying pixels will be clipped to absolute white, and is intended to take care of any bright error pixels that tend to be exaggerated. Visually it can also be useful to give a more photographic feel to the image by making sure the whites are pure (like dragging the end-point in Photoshop Levels). This also brightens the image by pushing all the tones right. The default is a slight clipping of 0.25% on a scale from 0 to 10%.

Black Point
This slider sets the point beyond which outlying pixels will be clipped to pure black, and is intended to take care of any dark error pixels that tend to be exaggerated by the tonemapping. As with the White Point slider, it can also give a more photographic feel to the image by making sure the blacks are really black. In the course of doing this, it also darkens the image by pushing all the tones to the left. The default is no clipping, 0 on a scale from 0 to 10%.

Gamma
This gamma correction slider works in the same way as in Photoshop, namely it darkens or brightens the image without clipping highlights or shadows. Gamma is actually a power function that applies a weighted curve. Here, moving the slider to the left raises the gamma above 1, slightly compresses the shadows and expands the highlights, making the image look darker. Moving the slider to the right lowers the gamma, slightly expands the shadows and compresses the highlights, making the image look brighter. The range is 2.00 on the left (darkest) to 0.35 on the right (lightest) and the default is 1. In Photomatix as with most other TMOs, the gamma slider is designed to be a post-tonemapping

imagine, is simpler to use, produces results that avoid the artificiality problems of local operators, but cannot really handle extreme dynamic range. It is well suited to medium-high range scenes. The more serious method, Details Enhancer, is what I'll concentrate on here. This is currently the most feature-rich tonemapping operator aimed at producing realistic-looking photographs. You'll notice that I qualified that last statement, because HDR has other, non-photographic uses, such as movie special effects and games.

control—a final tweaking of overall brightness to taste. It is often not needed. It bears comparison with the Luminosity control (see page 80).

Color sub-menu
Offers fine control over color only, separate from brightness and contrast. Combines a color temperature filter with saturation controls focused separately on highlights and shadows, to address some common tonemapping problems.

Temperature
Adjusts the overall color temperature from high (bluish) at left to low (straw-colored) at right. The digital equivalent of choosing a traditional photographic light-balancing filter from the straw-colored-to-bluish Wratten series. The scale is arbitrary from -10 on the left (roughly a Wratten 82C) to +10 on the right (Wratten 85C), and the default is 0. Another way of looking at this is a mired shift of about 40 towards bluish and about 90 towards straw-colored.

Saturation Highlights
Like the Color saturation slider, but operates only on the brighter pixels. Desaturate to the left, stronger saturation to the right. Useful in the frequent circumstances when the tonemapping exaggerates saturation in highlights; move the slider to the left. The scale is arbitrary from -10 on the left to +10 on the right, and the default at 0.

Saturation Shadows
As above, but restricted to the darker pixels. Shadow areas when tonemapped sometimes have reduced saturation; correct that by moving the slider right. The scale is arbitrary from -10 on the left to +10 on the right, and the default at 0.

Micro sub-menu
Offers control over the small-scale contrast, on a level of a few pixels only. The visible effect is one of different degrees of crispness and noisiness.

Microcontrast
Controls the accentuation of local contrast, on a scale of several pixels. Moving the slider to the left reduces local, small-scale contrast and brightens the image.

Moving the slider to the right increases small-scale contrast (sometimes also accentuating noise) and darkens the image somewhat. You might call it the "crispness" of the image. The scale is from -10 on the left to +10 on the right, with the default 0.

Micro-smoothing
Works usefully in combination with Microcontrast, smoothing out the enhancement of details on a small scale. Moving the slider to the right can give a cleaner appearance to the image, reducing low-frequency noise such as in a sky (and so can be useful if the Luminosity is set high). The scale is from 0 on the left to 30 on the right, defaulting to 2 for a slight effect.

S/H (shadow/highlight) sub-menu
Three sliders make useful adjustments to the extremes of the tonal scale.

Highlights Smoothing
This slider brightens the highlights only, which can be useful both for improving contrast and for reducing halo effects. On a scale from 0 to 100, with default at 0.

Shadows Smoothing
This slider brightens just the shadows, with the effect of reducing overall contrast. While there are few reasons for doing this on its own, this slider is useful for softening the effect of the third slider, Shadows Clipping. On a scale from 0 to 100, with default at 0.

Shadows Clipping
This slider clips the shadows to black. Used on its own, the effect can be hard and unnatural, but the Shadows Smoothing slider makes this more gentle and believable. Although this loses information, it increases overall contrast and tends to produce a more photographic look. Moreover, it is useful for removing noise in the darkest tones that resists removal by Micro-smoothing. Note that, unlike increasing the Black Point in the Tone sub-menu, this slider affects only the darkest tones, and does not push the rest of the tones towards a darker result (you can see this in the histogram).

Planning the mapping

1 First identify the type of HDR image, in order to anticipate the likely problems and issues.

2 Generate the HDR, and save.

3 Open the tonemapping window and either set to Default or Load the settings that you have already refined and saved for this type of image. In either case, these settings are the starting point.

4 Choose the largest preview size for accuracy, but be aware that the larger your file size, the less likely it will match the preview when finally tonemapped. Very large stitched images are especially prone to this kind of mismatch.

5 Address the major issues first, staying as much as possible to the top four controls (the lower four sub-menus are mainly for fine-tuning). Likely issues may be halos, overall brightness, color temperature (in the last case, go directly to the Color sub-menu).

6 Continue with refinements in the sub-menus.

7 When you are satisfied with the settings, Save them as an .xmp file in any convenient place, for future recall.

8 Save the tonemapping as a TIFF in 16-bit (the extra bit-depth because post-processing will often be needed).

Effects summary

Under each heading, the controls are listed roughly in order of how strongly they create the effect. With lightening and darkening, most of the controls have some effect, but often this is subsidiary to their other effects. Note that as contrast adjustments are at the heart of tonemapping, there are different spatial scales of contrast: those affecting the entire image (overall), those concentrated in the middle and slightly darker tones (mid-tone), and those across just a few pixels which have the effect of boosting detail (small-scale). Of the three scales of contrast listed here, some sliders have opposing effects; for instance, extreme Microsmoothing of Highlights may increase mid-tone contrast at the same time as reducing by smoothing out small-scale contrast. The directions given are from the default slider position.

Overall lightening
Luminosity to the right
Gamma to the right
Tone sub-menu White Point to the right (moderate effect)
Strength to the left (slight effect)
Micro sub-menu Micro-contrast to the right (slight effect)
Light smoothing to the left (slight effect)
Micro sub-menu Microsmoothing to the right (very slight effect)

Overall darkening
Luminosity to the left
Tone sub-menu Gamma to the left
Tone sub-menu Black Point to the right (moderate effect)
Tone sub-menu White Point to the left (slight)
Strength to the right (slight effect)
Micro sub-menu Micro-contrast to the right (slight effect)
Light smoothing to the right (slight)

Increasing overall contrast
S/H sub-menu Highlights Smoothing to the right
S/H sub-menu Shadows Clipping to the right softened by Shadows Smoothing to the right
Tone sub-menu White Point to the right
Tone sub-menu Black Point to the right
Strength to the right (moderate)

Increasing mid-tone contrast
Luminosity to the right
Light Smoothing to the left
Tone sub-menu Gamma to the left (moderate)
Tone sub-menu White Point to the right (moderate)
Tone sub-menu Black Point to the right (moderate)

Increasing small-scale contrast and fine details
Strength to the right
Micro sub-menu Microcontrast to the right

Decreasing overall contrast
Strength to the left (moderate)
S/H sub-menu Shadows Smoothing to the right (moderate)
Tone sub-menu White Point to the left (slight)

Decreasing mid-tone contrast
Luminosity to the left
Light Smoothing to the right
Tone sub-menu Gamma to the right (moderate)
Tone sub-menu White Point to the left (slight)
Micro sub-menu Micro-smoothing to the right (slight)

Decreasing small-scale contrast and fine details
Strength to the left
Micro sub-menu Micro-smoothing to the right

Decreasing halos
Strength to the left
Light Smoothing to the right
S/H sub-menu Highlights Smoothing to the right

Decreasing color saturation
Color saturation to the left
Color sub-menu Saturation Highlights to the left
Color sub-menu Saturation Shadows to the left

Decreasing noise
Micro sub-menu Micro-smoothing to the right
S/H sub-menu Shadows Clipping to the right. softened by Shadows Smoothing to the right

Light Smoothing

This user parameter, available only as 5 fixed settings (no intermediate values, so no slider), offers the greatest choice of effect on most images. This example, a modern light fitting on a wall, was chosen for its high dynamic range (between 4 and 5 orders of magnitude, captured in 6 source images 2 stops apart). It was also chosen because any haloing and tone reversals would not be objectionable, due to the complexity and unfamiliarity of its reflections, refractions, and shadows.

The top row shows the chosen tonemapping for the 5 Light Smoothing positions, from very low at left to very high at right. The bottom row, easier to compare, have been optimized with post-processing as follows: black point closed in slightly, unsharp masking at 20% intensity and 80 pixels radius, with the gamma adjuster in Levels matched to the first image.

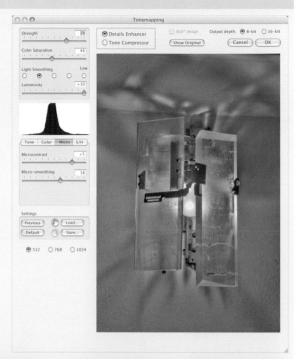

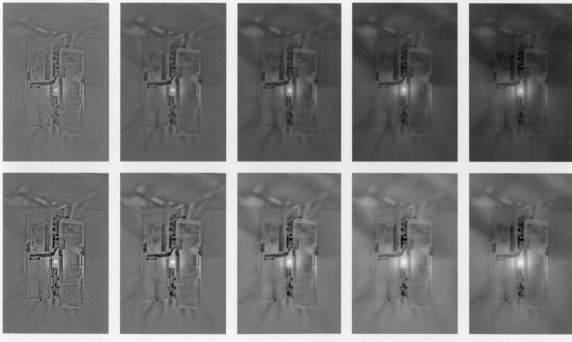

Luminosity vs. Gamma

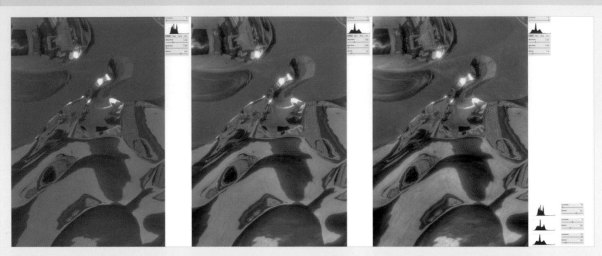

Both of these controls alter the overall brightness of the image and its mid-scale contrast, but in slightly different ways. The most significant difference is that Luminosity increases contrast as it lightens, more than Gamma does (both sliders moving to the right). So, using both together, in opposite directions, it is possible to alter the mid-scale

contrast alone, as shown by the three versions of this photograph of reflections in an abstract steel sculpture. From left to right: low Luminosity/low Gamma, default (mid) settings, and high Luminosity/high Gamma. The balance between the two sliders was adjusted for a visual match of the smooth mid-tone area at the top of the image.

Luminosity -10 (minimum)

Luminosity 0 (default)

Luminosity +10 (maximum)

Gamma 2.00

Gamma 1.00

Gamma 0.35

These histograms for the same image show what happens at the absolute lowest and highest settings. The Gamma slider has a larger range of brightness because the lowest setting (brightest) reaches 0.35.

Microcontrast and Micro-smoothing

These two sliders control the very fine level of detail, on a scale of just a few pixels, and so deal with not just detailed edges but also fine texture and noise (which on this scale can only be distinguished from real detail by your own visual judgement). The two sliders work very well in tandem, and are indeed meant to be used together. In order to see the effect during tonemapping, you will need a 100% view, which Photomatix provides via the cursor—as it rolls over the preview image, it displays a magnifying glass icon. Simply click and you are presented with a 100% preview covering a small area. As with most other controls, the importance of these sliders varies from image to image. In the example here the effects are significant but subtle. The defaults are 0 for Microcontrast (there are hardly any circumstances in which you would want to reduce the strength) and 2 for Micro-smoothing. As these sequences show, increasing Microcontrast has an effect on edges similar to traditional edge-sharpening but without haloing, and a crispening effect on texture. This also means an exaggeration of noise. Micro-smoothing does as its name suggests, and smooths out this detail enhancement in a way similar to a selectively applying a median filter. Increasing the strength of both together aims for the best of both worlds—at least in the case of this image. The appropriate strengths will vary according to the image and its content.

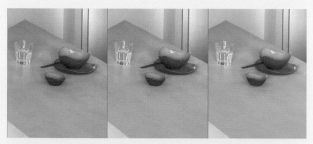

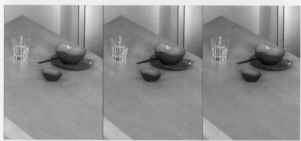

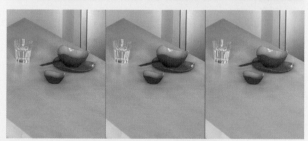

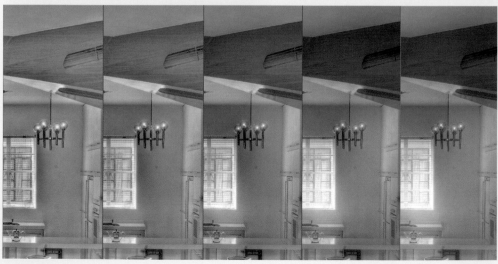

Photoshop

Adobe introduced HDR capabilities into Photoshop CS2 in 2006, though without much fanfare and somewhat tucked away.

The generation part is under *File > Automate > Merge to HDR*, while the tonemapping happens as part of changing Mode from 32-bit to 16-bit or 8-bit. Nothing was added or altered with the CS3 product cycle and we can probably assume that it is still considered to have niche status. Photoshop offers four tonemapping operators. The first three are extremely simple global operators which have almost no practical application for photography, but the fourth is an interesting local operator with special appeal — its main control is a curve overlaid on a histogram and so quite intuitive to use. The controls are described fully in the box on page 89. Here, we work through two different images to get a feel for the workflow. Being curve-based for the most part, this often becomes a detailed process with many small steps.

Japanese room

This traditional tatami room, photographed in daylight with the paper-covered window fully in view, is moderately difficult. The dynamic range is quite high, covering 13 stops, and shot in a sequence of 5 frames with the usual separation of 2 stops. Note that the light source is in view, but it is a diffused light source (typical of this kind of interior), with a corresponding broad lens flare. We saw this image earlier under Flare on pages 56-57, with a comparison between Photosphere's flare removal and the version here. In this section we'll do everything within Photoshop.

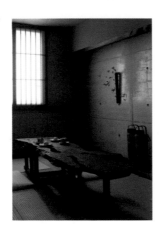

First, a quick run-through of the four tonemapping options, the first three as usual of only passing interest. Local Adaptation is the only operator in Photoshop to merit serious attention, and the sequence here shows the gradual application of points to the curve corresponding to known points in the image. The final result is fine except for the lens flare, which has to be tackled in post-production. Refer, however, to Flare on page 56 to see how much better the result is from the identical tonemapping when the original is created in Photosphere with flare removal.

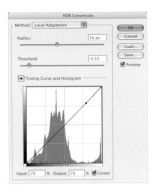

The window occupies a distinct part of the histogram, the peak and slope at far right. In order to be able to deal with this separately, the first point on the curve is set just below it, and made into a corner.

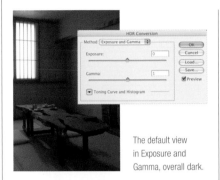

The default view in Exposure and Gamma, overall dark.

Equalize Histogram works well for mid-tones, but fails to compress highlights and deep shadows satisfactorily.

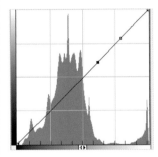

As there is a 'dead' area of light tones on the right-hand side (the image jumps in brightness from the window to the light-mid-tones on the wall), we will block this off with a second corner point so that we can work purely on the darker tones in the left half.

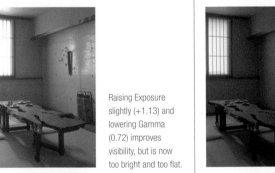

Raising Exposure slightly (+1.13) and lowering Gamma (0.72) improves visibility, but is now too bright and too flat.

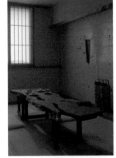

Local Adaptation default view, overall dull, though not as strange as it often is, as the distribution of tones covers most of the histogram range.

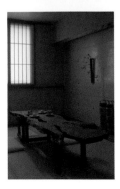

Highlight Compression (there are no options to tweak) handles the window well, but nothing else.

Clicking on the image shows where tones lie on the histogram. here, the key peaks are identified, and some of these will become useful anchors when we begin to adjust the curve.

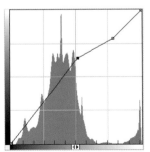

One of the basic principles of curve adjustment with an HDR image is to follow the shape of the histogram (partially), we can move this second corner point up to near the right-hand 'start' of the bulk of the tones.

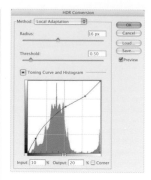

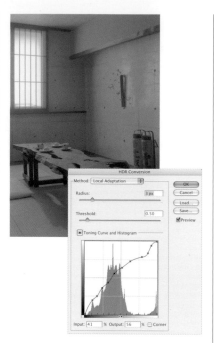

The shadow tones on the table legs are important.
We want a hint of detail and to raise them above black.
Conveniently, they occupy a sharp peak at left, and this
is the location for the 3rd point. This is not a corner point,
so it automatically raises the curve above it.

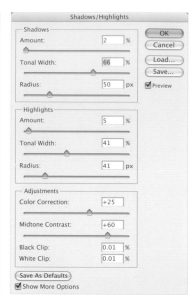

We now begin to adjust the three distinct sections of the
curve. First, we enhance contrast in the window highlights
by dragging the lower part of this small section down to
Input 87, Output 84 (the upper anchor is already as high
as we want it).

Having perfected the curve, experiment with a low Radius.
This is no improvement; the image loses crispness.

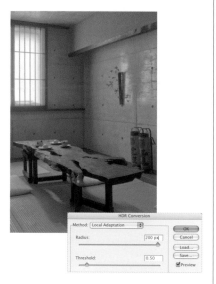

Next, we slightly raise the middle section to lighten the
light-mid-tones just a little, to separate them from the
bulk of the mid-tones (new handle at In 63, Output 73).

Next a very high Radius. This too is no better than the
default, and exaggerates the reflections on the right-hand
wall to the point of looking almost posterized. The result
is (having also experimented with Threshold) to settle for
the defaults.

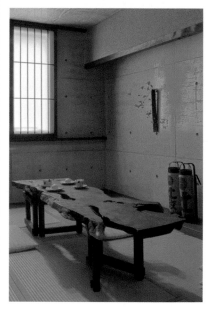

As anticipated, the lens flare in the upper left of the
image is unsatisfactory, and could not have been tackled
during tonemapping in Photoshop. This is handled in
post-production on the 16-bit TIFF by the time-honored
practice of brushing over the area in Quick Mask and
then adjusting contrast and brightness. Traditionally,
this would have been done in Curves, but here Shadow/
Highlight gives far more useful control. A second pass is
still necessary for the far left window frame, which is later
cropped into slightly.

University cloister

For a second image, we take a strongly upward-angled view with a very wide-angle lens (12mm on my Nikon, the equivalent on a 35mm camera of 18mm), in the shade of a gallery looking through to bright sunshine. The range here is rather less, at 10 stops, covered in just 3 frames separated by 2 stops each. In fact, the sequence could have done with a fourth, even lighter frame, and this will reduce the work needed to open up the shadows in the ceiling.

The first important point here is that Photoshop CS3 allows a reasonable amount of image editing directly on the 32-bit HDR file. So, rather than leave this operation until 16-bit post-production, the perspective, scaling and cropping adjustments are made first. The main feature of this image is strong segmentation — clearly defined brighter areas within the frames of the arches.

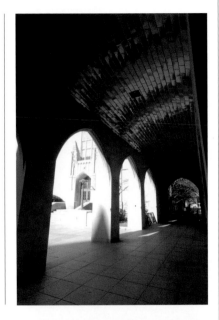

The HDR file as created and opened in 32-bit. The Perspective tool followed by the Scale tool are applied, and the image then cropped.

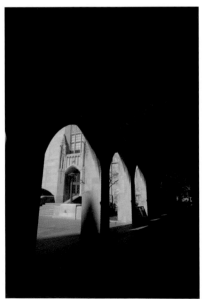

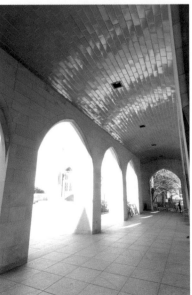

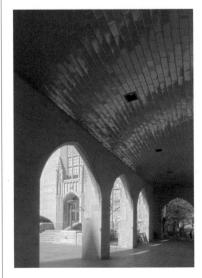

The image as it opens in default Local Adaptation, pale and flat as is usual.

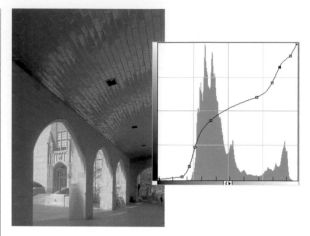

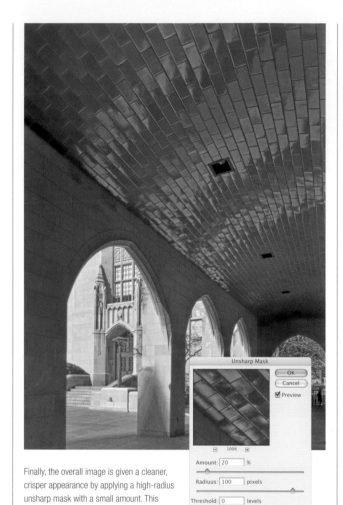

Note that the histogram shows that the tones sit well within the scale, particularly on the left (darker) side. The first thing needed is to close up the curve with a corner point at lower left and another at upper right. All the subsequent curve adjustment takes place in the centre section between these corner points. There will still be considerable post-production needed.

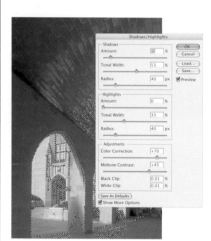

There is strong segmentation, and this suggests doing post-production work separately on the brighter and then darker areas. Fortunately, creating a luminosity mask (by clicking on the lower left icon in the Channels palette) automatically selects the lighter 50% of the tones. Shadow/Highlight is used, with Highlights adjustment turned off to improve contrast.

Finally, the overall image is given a cleaner, crisper appearance by applying a high-radius unsharp mask with a small amount. This improves the mid-scale contrast.

Next, contrast is improved in the darker tones by inverting the selection and applying Shadow/Highlight with the Shadows adjustment turned off.

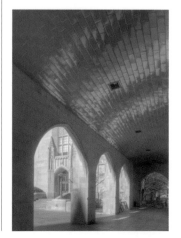

For comparison, here is the best possible version of the same image tonemapped in Photomatix, with the same post-production work. The differences are a matter of taste.

The Photoshop tonemapping controls

Exposure and Gamma

This is a global operator, offering the most basic of all adjustments; a paired Exposure slider and Gamma slider. The two are intended to be used together. Exposure, on a scale from -20 to 20, mimics the effect of exposure differences at the time of shooting, by moving the entire range of tones, including the black and white points at the ends, towards darker or brighter. The effect is a lowering of brightness when the slider is moved to the left, accompanied by loss of shadow detail (that is, black clipping), or a raising of brightness when the slider is moved to the right, accompanied by loss of highlight details (that is, white clipping). The Gamma slider, as described earlier (pages 22-23 and the same control in Photomatix on page 78), does not alter the black and white points, so that there is no clipping of highlights or shadows. It has the effect of compressing shadows and expanding highlights while darkening the image when raised (moved to the right, or expanding shadows and compressing highlights at the same time as lightening the image when lowered (moved to the left). This means that it also has the effect of heightening overall contrast when raised or lowering it when reduced. In other words, it is not quite so simple as the Adobe recommendations ("exposure and gamma, which serve as the equivalent to brightness and contrast adjustment, respectively") suggest. Both sliders affect brightness, but in different ways. It is usually not possible to achieve a satisfactory balance of brightness and contrast with this method.

Highlight Compression

This method, also a global operator, has no options. Instead, a custom tonal curve is applied, designed to reduce highlight contrast drastically in order to brighten and restore contrast in the rest of the image. It is rarely satisfactory, and the usual result is gloomy.

Equalize Histogram

This method, the third global operator in the set, attempts, in Adobe's own words, "to redistribute the HDR histogram into the contrast range of a normal 16 or 8-bit image." It does this by applying a different custom tonal curve which evens out the peaks in the histogram, hence the term "equalize." Of the three global methods, this is the only one that occasionally produces a useful result, but more often not. Adobe suggest that it works best when the image histogram has several relatively narrow peaks with no pixels in between. There are no options with this method.

Local Adaptation

This is Photoshop's local tonemapping operator, and so the one that is most useful. In fact, it combines a local operator with global operations, and the relative weighting towards one or the other is set by the two sliders, Radius and Threshold. Specifically, Radius controls the area around each pixel that is used to determine the local contrast enhancement—as with other programs this is very much at the heart of a local operator. A moderately low Radius setting means that each pixel is adjusted in relation to a small neighborhood of surrounding pixels, and the effect tends to be one of stronger, crisper detail, though sometimes with the risk of an artificial appearance. If very low, however, the image is likely to lose crispness. A high Radius works over a broader area of the image, but at very high settings may create strange large-scale tonal changes and broad halos. As always, I qualify these remarks because different images respond in different ways.

The Threshold slider determines which tonal values are included in the local neighborhood set by the Radius. The higher it is, the stronger the local contrast, but at the same time the greater the risk of halos.

Because the major adjustments with this method are made by altering the curve, my preference is to leave the Radius and Threshold settings on default, and experiment with them last. The effect varies from image to image, but is easy enough to preview quickly by moving the slider left and right. A quick extreme movement shows the kind of change. The default, 16 pixels, is often appropriate as is the default Threshold of 0.50.

The curve that accompanies this method, accessed by clicking the drop-down Toning Curve and Histogram, is currently unique among tonemapping software as a control, and it has an obvious appeal to photographers who are familiar with applying tone-correction curves in ordinary, low dynamic range photography. There are some important differences, however, between this curve and the one that can be used on 8-bit and 16-bit images under *Image > Curves*. The first is that it covers the entire tonal range possible, and for most HDR images this is greater than needed. The underlying histogram visible in the window usefully shows this. Practically, it means that the default display when you select this method often looks severely artificial, lacking very dark and very dark tones yet with hyper-saturated colors.

The immediate step, therefore, is to limit the range, either by dragging the end-points of the curve to the limits of the histogram, or by clicking on the curve itself at two points, each near one end, and dragging the curve towards the limits of the histogram. With this second method, it often helps to make use of the second special feature of this curve—the so-called "Corners."

Once you have made an adjustment point on the curve, checking the tick box Corner makes it into a kind of break-point on the curve, which is elsewhere known as a knee or knee-point. Effectively, this breaks the effect of any other curve adjustments above or below it. It is a useful way of dividing the curve into completely separate sections, uninfluenced by each other. This option is particularly useful with HDR images because of the likelihood of extensive and complex adjustments to different parts of the tonal range. Note that because the curve can be dragged into almost any shape, it is easy to create tone reversals (see page 36), in which different tones next to each other can cross positions, which looks disturbing.

FDRTools

FDRTools has some particular features that distinguish it from the other HDR software on the market.

The FDRTools tonemapping controls

These are intentionally few, although the algorithms behind them are no less powerful for that. The upper three sliders control the local tonemapping, and the lower ones are post-processing adjustments— the usual black point, white point, gamma and color saturation that you would otherwise use afterward in Photoshop. As is common with commercial HDR software aimed at the photography market, the controls affect both local and global contrast.

Compressor
On a scale from 0 to 10, with default in the middle at 5.0, this controls the strength of the tonemapping, with a greater effect on local contrast than on global. The higher the dynamic range of the sequence of original exposures, the higher the strength that is likely to be needed. Equally, though, if the dynamic range is not high by HDR standards, high values for this slider will produce a general flattening of the appearance, together with a kind of veiling fog across strong luminosity edges.

Contrast
This slider, on the same scale from 0 to 10 and default at 5.0, affects large-scale and mid-scale contrast, and as such complements the Compressor. In general, increasing the value (to the right) yields improved overall contrast. There is an optimal value for this, but it depends on the dynamic range of the particular scene. If the dynamic range is not high, high Contrast values will, like the Compressor slider, produce a flat overall appearance. A tendency toward haloing accompanies high values, as you would expect, but if the Compressor values are also high, they tend to cancel each other out in this often important area.

Smoothing
This slider, with the same scale and default position, is intended to smooth out any harsh intensity differences due to positions of the upper two sliders. It acts, says the developer, "like a glue between Compression and Contrast." It is particularly valuable when there are large evenly-toned areas, such as a sky or an interior white wall. In the sequence of trying out the three settings, this usually comes last.

We've already seen (on page 48) the way in which FDRTools integrates HDR generation with tonemapping. This effectively broadens the entire procedure, so that, for example, you could use the weighting of the source images to affect the outcome.

For tonemapping, there are three methods, called Simplex, Receptor, and Compressor, but the one we will pay attention to is the latter, which is the most powerful and a local operator with additional global actions. Simplex is fast but useful only for a quick preview, while Receptor is a global operator. Beware of making comparisons between software based on names—Photomatix Tone Compressor is the less effective global operator, while FDRTools Compressor is the powerful method.

The developer's intention is to keep the tonemapping operation simple, by reducing the number of sliders (user parameters) and by limiting the range of their effect to useful results. Direct comparison between these sliders and those in other HDR software is pointless; they work in different ways, even though aimed at similar results. There are three sliders intended to be used together, with top to bottom being the usual sequence of adjustment. Below these, and following these, are what the developer rightly calls post-processing operations—gamma adjustment, black and white points, and color saturation.

Compression vs. Contrast, with Smoothing

0-0-0 0-0-0 0-0-10

5-5-0 5-5-5 5-5-10

10-10-5 10-10-5 10-10-10

This matrix showing the combined effect of low-to-high Compression and Contrast, then with Smoothing added (more smoothing as you move to the right). Note that this image has only a medium-high dynamic range, and the extreme settings are far too aggressive for it. They would be more appropriate for an image with very high dynamic range, such as with a light source in view. Nevertheless, this image is typical of many graded-sky shots that include a sharp luminosity edge, with the attendant haloing issues.

Sequence and settings

The simple choice of sliders keeps tonemapping relatively quick. The default settings of 5, 5, 5 usually displays an acceptable result, or at least a starting point. As with all HDR software, if the image has a lot of small-to-medium detail and little in the way of large, evenly-toned areas, things are always easier. Another way of putting this, more from a software developer's point of view, is that tonemapping tends to have most success when an image is full of high-frequency components (detail) rather than low-frequency components (large, smooth regions).

As a rule of thumb, scenes and images with a medium-high dynamic range do well around the default settings, while high dynamic ranges need stronger settings. A good working plan is to work from top to bottom, beginning with the Compressor slider. Take it to extremes to get a feeling for the range of effects possible with this particular image, then work back from there to a setting that appears to give the best small-scale contrast. Use the Preview window for a 100% view; clicking on the Navigator window opens the view in that spot in the Preview. Also, the Preview window can be enlarged and changed in shape to take advantage of a large display. Next, move to the Contrast slider, again moving it quickly to extremes to gauge the possibilities. Remember that this is adding to the Compressor effect, so that if the image does not improve to your liking, go back to the Compressor and re-adjust. Higher Contrast settings should enhance the larger scales of contrast, which are often a weak point in tonempaping. Finally, when the combination of both Compressor and Contrast is roughly in the right zone of appearance, move on to Smoothing. This third slider is important for handling low-frequency components—large areas of fairly even or smoothly graded tones—and its higher settings will do what its name suggests.

Seven source images loaded. The Separation window shows which parts of which tonal range are being combined to make the HDR.

The Simplex window with simple controls.

The Receptor global operator window.

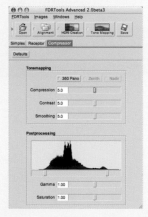

The Compressor local operator window at default settings.

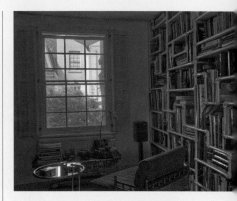

Here the Compression slider in the Compressor window has been raised to 9, as this image has a high dynamic range.

After which the Contrast is raised to 8.5 for increased mid-scale contrast.

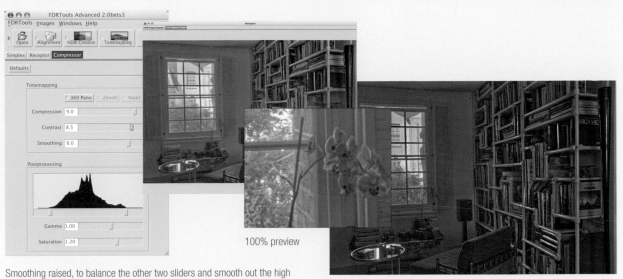

100% preview

Smoothing raised, to balance the other two sliders and smooth out the high values in particular. Then Saturation increased, paying attention to the orchid in the 100% Preview window.

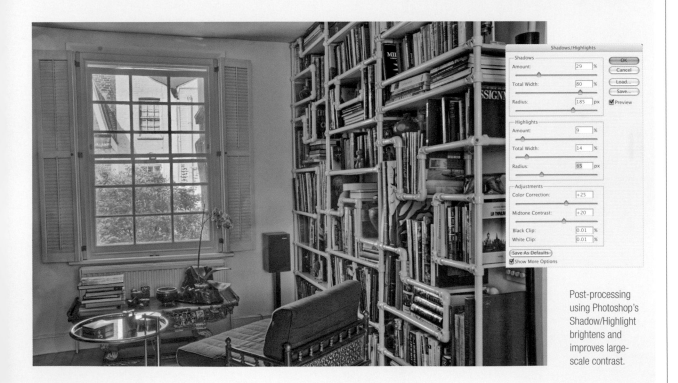

Post-processing using Photoshop's Shadow/Highlight brightens and improves large-scale contrast.

PFSTools

Using the cross-platform framework Qtpfsgui, PFSTools offer access to the key selection of "academic" tonemapping operators.

The "academic" algorithms are the foundation of all current commercial TMOs, although the amount of development that has gone on in operators such as Photomatix and FDRTools is very obvious. Ultimately, this selection of operators is interesting and instructive rather than practically useful for photography.

The interface is clean and well-designed, and gamma pre-processing (effects difficult to predict) and post-processing are available separately for all the operators. There are few frills, for instance Apply needs to be clicked each time you make an adjustment to see the result. Sensibly, there is a choice of image preview sizes from thumbnail all the way up to full size; smaller is faster, but a full-size preview is available for fine checking. Applying changes to the full-size takes a long time, but once complete, Saving is almost instantaneous.

All the operators shown on here are available, and clicking each gives a small preview with the (recommended) default settings.

Each of these operators works on quite different principles, as their names suggest. For example, the Pattanaik operator is global, and time-dependent in that it mimics the rod and cone response of the human eye (so shadows show less color). Nevertheless, it also offers a local-contrast option.

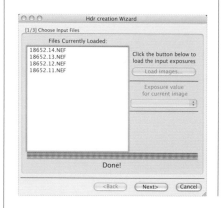

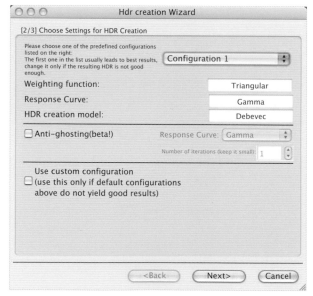

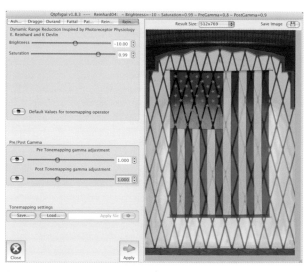

Reinhard04: dynamic range reduction inspired by receptor physiology.

Ashikhmin: a tonemapping algorithm for high contrast Images

Drago03: adaptive logarithmic mapping for displaying high contrast scenes

Fattal02: gradient domain high dynamic range compression

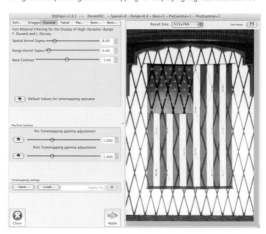

Durand: fast Bilateral Filtering for the Display of High-Dynamic-Range Images

Pattanaik00: time-dependent visual adaptation for realistic image display

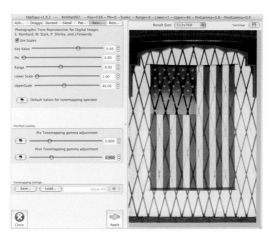

Reinhard02: photographic tone reproduction for digital images

The controls are in the form of sliders, for each of the user parameters available, but these are not explained, and in order to make sensible use of them you would need to read the original research papers (available on the Web) or the standard book "High Dynamic Range Imaging" by Reinhard, Ward, et al. The best procedure is to keep the preview very small and click through the seven operators to see which, on default, shows the most promise. Then enlarge the preview to one of the mid-sizes and adjust the sliders one by one. If the results begin to go in an unsatisfactory direction, click Default Values and begin again. If possible, leave the Pre and Post Gamma until the end. Post Gamma is more predictable than Pre Gamma, and the two typically need to be adjusted together. Once the mid-sized preview looks as good as possible, select the largest preview, which is full size, click Apply and wait. Once this had been processed, check the fine details, and when you are satisfied, click Save Image in the top right

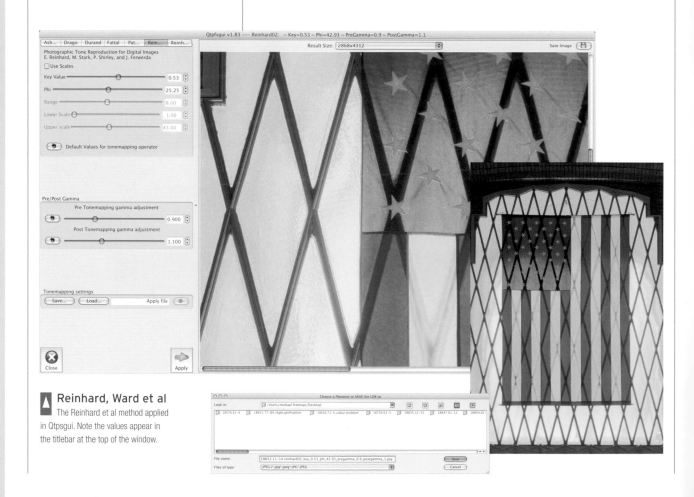

▲ **Reinhard, Ward et al**
The Reinhard et al method applied in Qtpsgui. Note the values appear in the titlebar at the top of the window.

corner of the window. Usefully, the slider settings (the user parameters) are automatically shown in the Save as... filename.

In the examples here, I've taken two operators, Pattanaik's and Reinhard's Photographic and adjusted the settings to get as close as possible to a "photographic" result. For comparison are the best-possible versions from Photomatix and FDRTools. Because of an overall yellow-green cast to the window behind the flag, color correction in Curves has been applied to each of the results, mainly in the form of increasing the high tones of blue. No other post-processing corrections were made.

Clearly evident is the extra work that has gone into the two commercial operators. The treatment of the diamond-pattern window leading behind the flag's white stripes, where they are diffused, shows haloing and edge problems in the Pattanaik and Reinhard TMOs.

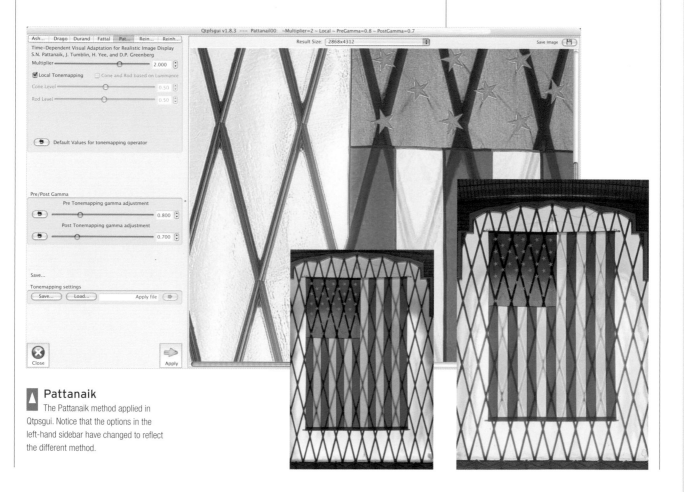

Pattanaik
The Pattanaik method applied in Qtpsgui. Notice that the options in the left-hand sidebar have changed to reflect the different method.

EasyHDR

This software runs on Windows only, not Mac OS, but it offers some useful options to that platform.

EasyHDR's most powerful features are in a local operator, but it combines this with a global operator that can also be used to post-process the locally tonemapped image within the application. The global operator is always active (and intended for post-processing), but checking "Mask" enables the local operator. For a little bit more on each of these controls, check the boxes below.

Local operators

Strength
This has its greatest effect on the brighter areas by attenuating them, increasing their local contrast so that in a bright sky, for example, colors and tones are strengthened. It also tends to lighten shadow areas to some extent. Excessively used, it can create halos.

Brightness
This slider is intended to tune the shadows, though use with caution so they are not over-lightened. It is, in fact, a pre-processing gamma adjustment. If the image appears too dark at the default settings, this may be the first slider to adjust.

Smoothness
This setting controls the smoothness of the tonemapping mask. Lower (slider to the left) reduces mid-scale contrast, but can also also increase haloing and make halos narrower (so often more noticeable). Increasing smoothness (to the right) improves the natural "photographic" appearance.

Edge
Increasing this slider can make slight reductions to any halo effect.

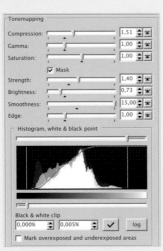

Global operators

Compression
Compresses global contrast (reduces global contrast), while at the same time preserving and even boosting color saturation. Overall lightening effect when increased. It is good to tune the Compression control before adjusting the Gamma one, because gamma adjustments cause the resulting photograph to lose color information. (The Increased Compression option creates greater global contrast reduction, with mostly shadow affected. At the same time color information is preserved.)

Gamma
Standard Gamma correction, intended to be used to balance (counter) the lightening and contrast effect of the Compression slider.

Saturation
Color saturation. May not be needed, and is intended as a final adjustment.

Curve adjust
This operates in much the same way as the Photoshop Local Adaptation method, and is useful because it is intuitive. By setting knee points, individual sections of the curve can be manipulated (see Photoshop page 84).

Black and white clip
As with other HDR software, moving in the black and white points clips tones at the extremes of the scale, but this is useful for helping to make the image seem photographically natural. They increase global contrast when moved in.

Typical workflow

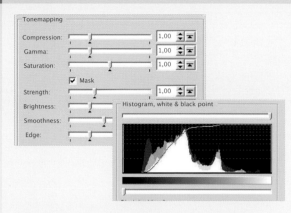

There is slightly too much violet in the shadows. Using the "Sample/target balance" tool, the offending area can be targeted by sampling with the dropper, and then adjusted in the Select color window.

Once the HDR is generated (see pages 46-49 for loading and generating), the size of the image is automatically reduced to meet the criterion that can be set in the Program Options. Also, the preview is calculated automatically. The Mask checkbox can be clicked to enable the local operator.

At 12 megapixels, this is a relatively large image, suggesting an increase in smoothness for the tonemapping mask. Clicking on the histogram toggles between 3-channel and luminosity mode.

Next, Strength. Raising the value attenuates the bright areas, making them darker and improving their small-scale contrast, but at the same time brightening the shadows below.

Brightness is decreased slightly, to compensate for the shadow lightening from increasing the Strength.

Increasing Compression reduces large-scale contrast and lightens somewhat.

The black and white points are moved in from the outer limits, trimming the histogram. Checking the "Mark overexposed and underexposed areas" checkbox reveals which areas, if any, are clipped.

Next, a delicate adjustment to the curves tool.

A number of filters, including gaussian blur and USM, are available for use on the HDR file.

The result.

Halo control

Because of the way in which most TMOs work, searching around each pixel and often using blurring in order to define its "neighborhood" of pixels, halos are a common problem.

Halos are most likely to occur at sharp edges between light and dark areas, also known as luminosity edges. This happens when an image is distinctly segmented in to light and dark, such as a roof against a sky, or a window frame. The appearance varies, but typically shows itself as a softly graded lightening or darkening close to the edge. If the area is relatively simple and smooth on both sides of the edge, you will notice two halos: a bright one in the lighter area and a dark one in the darker area. The problem is that the very technique used by the tonemapping operator to heighten local contrast is doing the same thing across the boundary. These kinds of algorithm cannot distinguish between contrast that we want and contrast that to us looks strange.

In almost all cases a halo looks unnatural and strange, and because it is relatively common in tonemapping it has quickly become viewed as a hallmark of poor technique. There are, nevertheless, exceptions. When the halo is very broad it begins to look simply like gradation, and in a sky this can

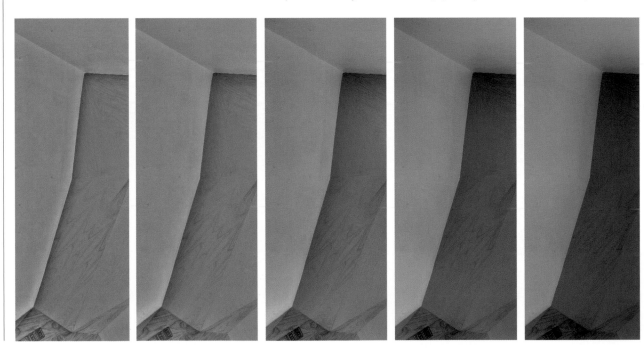

be attractive. Indeed, a broad gradation is exactly the effect of a clear dusk sky, and also from using a grad filter. One of the advantages of a gentle halo is that it subtly draws attention to the luminosity edge and so enhances the impression of contrast. Indeed, some painters have made use of this gradual increase in contrasting tone up to an edge in order to define shapes more strongly. Rembrandt in particular did this in his portraiture. Favoring low-key lighting and an almost monochromic palette, he often needed some means of separating the figure and background, and a gradual lightening of a dark background inward toward the figure or figures helped to define them, as in The Anatomy Lecture of Dr, Nicolaes Tulp (1623). When the subject of the photograph is slightly unusual, or at least not so completely familiar as a roof against a sky, there is more latitude for accepting halos. Look for example at shadows cast by the wall light in the pictures (left). They are complex to begin with, so that a high halo setting (courtesy of low Light Smoothing in Photomatix), does not look as offensive as it normally would.

There are two basic approaches to dealing with halos. One is to broaden the halo, for the reasons already given. The other is to reduce the haloing effect. Much depends on the software's features. First, let's look at halo width.

In Photomatix, the five Light Smoothing settings give the clearest choice in the width of halo, as the comparison here shows, and the two right-hand

▼ Light Smoothing in Photomatix
The most positive halo control in Photomatix is the Light Smoothing choice. Here, details of two separate areas of this halo-prone interior (large, evenly-toned areas with distinct luminosity edges) are shown in the 5 Light Smoothing positions, from very low at left to very high at right. In the lowest settings, halos are visible on both sides of the luminosity edge.

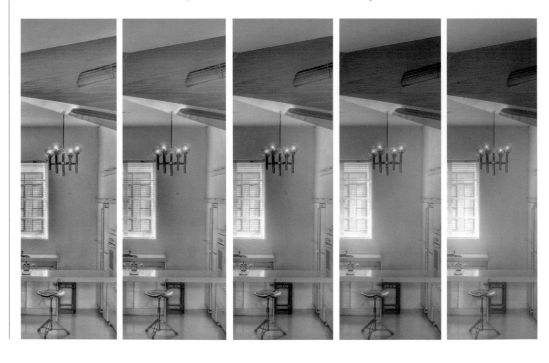

settings give the broadest and therefore least noticeable haloing. At the same time, however, there is less local contrast and so less separation of detail, particularly in the darker tones. There is also an overall darkening. The narrower haloing with the left-hand settings is also accompanied by increasing artificiality and less sense of depth, as this algorithm is affecting more than just the halo width.

With Photoshop's Local Adaptation TMO, the most control over halo width comes from the Radius slider, as you might expect. The three settings shown here for comparison are 10 pixels, 50 pixels and 100 pixels. Notice, however, that while a high radius makes the halos less obvious by making them broader and softer, a very low radius also works. Again, there are penalties in moving too far in either direction: In this image, even the highest radius is not sufficient for some of the edges (note the dark halo to the right of the window frame), while the very small radius loses contrast in the mid-range of scale (poor separation of the white wall surfaces).

With FDRTools, the intentionally simplified tonemapping controls offer halo control mainly through the Smoothing slider. The effects of this are

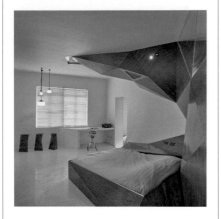

▲ Smoothing slider in FDRTools
Minimum to maximum settings for the Smoothing parameter on a similar image to that used for the Photomatix comparison. From left to right: Smoothing at 0.0, default 5.0 and 10.0.

similar, though less intense, than Photomatix Light Smoothing—more narrowly defined halos at low strength, combined with more apparent detail (particularly in the darker tones) and more artificiality.

Reducing the halo is a matter of evening out the tone on one or both sides of the luminosity edge. There are ways of doing this within tonemapping, but it may be necessary to tackle it in post-production, as in Photoshop. All of this can be time-consuming, which makes it important to find ways of simplifying the workflow. One method, put to use on page 72, is to make two tonemapped versions, then layer and erase unwanted areas. This is not an elegant solution, but works well. If one of the versions is tonemapped with a global operator, such as Photomatix's Tone Compressor, this will be largely halo-free. With normal post production techniques, the main problem lies in making a smooth selection over typically large areas of the image. Painting in a mask layer, even with a large soft brush, is difficult because it means matching the shading accurately. Procedural selection methods are likely to be more successful; for instance a luminosity mask (in Photoshop, the lower left icon in the Channels palette).

▼ Radius slider in Photoshop
The most effective control in Photoshop changes the width of the halo—a side effect of using the Radius slider. With a very low radius the width of the halo may be too small to be noticeable (underside of the wooden structure on the ceiling). Mid-settings generally make it prominent, while high settings spread it out further, so are generally less noticeable. The exact effect depends on the specific image. From left to right: Radius settings of 40, 50, 100, and 200 pixels.

Naturalness

If I had to list the ills of HDR photography, they would include halos, too much detail, no mystery, too few blacks and whites, and over-saturated colors.

Of the problems with HDR, some are down to difficulties in the computing (halos in particular), but most are because of ill-judged and excessive use. This is a very simple and short point to make, but of real importance. If HDR is to work as a tool for photography, it has to be used in a way that conforms to a natural appearance. For the many reasons that we went into in the HDR scenes and vision chapter, human perception is highly discerning. Among other things we know, or think we know, when something looks wrong, false, or unnatural. A century and a half of looking at photographs as a way of seeing the appearance of real things has given us all a good feeling for "natural." It happens to include a number of qualities that involve loss of information. These include dense shadows, to the point of things appearing in silhouette, washed out highlights, flare, things out of focus, and more. Tonemapping can reverse some of these losses — the tonal ones, anyway — but is that necessarily a good idea? It may seem paradoxical, but in one way the more visual information that we can bring out in an image, the less natural it will look. Certainly it will look less photographic, and if that is not exactly the same thing,

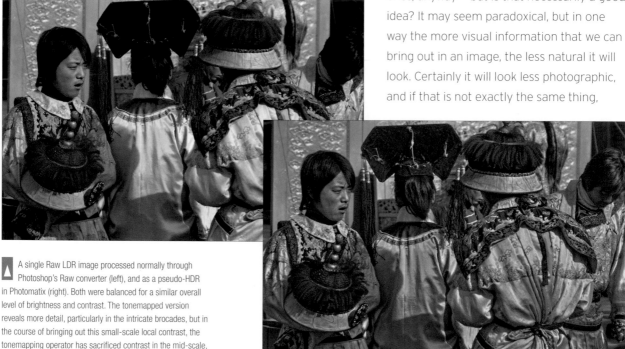

A single Raw LDR image processed normally through Photoshop's Raw converter (left), and as a pseudo-HDR in Photomatix (right). Both were balanced for a similar overall level of brightness and contrast. The tonemapped version reveals more detail, particularly in the intricate brocades, but in the course of bringing out this small-scale local contrast, the tonemapping operator has sacrificed contrast in the mid-scale, and has an acquired a somewhat artificial appearance.

it comes close to it. This tends to bother professional photographers, who are generally aiming at specific results, more than those amateurs who are simply experimenting. Particularly bothersome is the often poor rendering of what should be smooth, plain areas, such as a sky or a white wall (see the box "White-wall syndrome" on page 107).

Partly for this reason, some of the principles of organizing elements into a photograph — composition, if you like — involve concealment. One of the most common ways to achieve this, shown in the example on the opposite page, is letting a dark setting go to black in order to focus all the attention on a spotlit subject. We choose not to reveal in photography in order to strengthen the impact. It might not be a good idea to reverse this by allowing HDR and tonemapping always to do their work so thoroughly. I'll let the images on these three pages do most of the persuasion.

An HDR image generated from a sequence, processed mildly in FDRTools at left (Compression, Contrast and Smoothing settings of 6-4-7) and aggressively at right (settings of 10-10-2.4). The over-processed version hardly looks like a photograph anymore, although fine-scale detail is richly enhanced.

Spotlight and surround

The attractiveness of this image, of a young Burmese novice nun learning scriptures, comes from the very high contrast between the bright late afternoon winter sun streaming through the window and the intensely dark surroundings. Indeed, this was why I took the picture, on film, knowing what the effect would be. Had I shot this digitally and then tonemapped it, opening up the detail, the entire point of the picture would have been destroyed.

Hint of shadow detail

This photograph of the ruins of an ancient and remote Egyptian temple in northern Sudan was shot digitally, with a range of exposures. The effect I strived for, and I believe achieved, was twofold: the merest hint of shadow detail in the stone columns, and a low contrast for the two figures riding donkeys—so that there would be a delayed effect in noticing them. A pure black silhouette would have lacked volume, but opening up the shadows to see all the detail of the stone would have been worse.

▲ Abstraction from reflected lights

Another image that I like because of its uncertainty. This is a night view with a long lens of a canal in London, photographed for a magazine story on the revival of the English canal system. It is really not obvious at first what this is about, with the strange play of lights, but ultimately the scene resolves itself when the moored old canal boats become intelligible on the right bank. Without this mystery, the photograph would have been pedestrian.

▶ Flare and speculars

Yet another case when what are now called optical artifacts come to the rescue. The glow and the sparkle give an atmosphere rather than information, but then this is not an identification picture for a field guide.

White-wall syndrome

This is my personal term for an intractable problem with local tonemapping operators. In an interior with smoothly lit white walls, yet still a high dynamic range, the walls are likely to render not only patchy and with haloing, but as a muddy gray. This combination of effects is completely unsatisfactory, and with the present state of HDR software always needs post-production work. Typical solutions are to layer the locally tonemapped result with one of the single TIFFs that has acceptably white walls, or to layer it with a globally tonemapped result from the same HDR file—and then erase through to reveal the smoother, whiter walls.

The importance of post-processing

For a number of reasons already mentioned, including the technical problems in getting a tonemapping operator to be selective, some post-processing is almost inevitable.

It's better not to look at this as sorting out failure, but as a natural part of the procedure. There may be a variety of image issues to fine-tune, but one constant need is to make sure that the final image looks natural as a photograph.

Some HDR software actually includes some controls that would normally be considered post-processing, which makes the boundary between tonemapping and post-processing in Photoshop or a similar image editor rather hazy. For instance, black point, white point and gamma sliders — the familiar controls in Photoshop Levels — are available within Photomatix and FDRTools. Photomatix presents them in a sub-menu, FDRTools calls them post-processing, but in each case they supplant what you might later be expecting to do in Photoshop.

Everyone has his or her own preferred workflow for finishing off images, and it's as well to adapt this to an HDR workflow. Nevertheless, given the likely needs of a just-tonemapped image, consider the following procedures for post-processing:

1 Open in Photoshop (or your preferred image editor with the equivalent of the following).

2 Go to Levels and check the position of the black and white points. There should be the barest hint of clipping in one channel only at each end. In other words, both closed up but without significant clipping.

3 Unless there is strong segmentation into bright and dark zones, compare the effects of contrast enhancement overall from an S-curve in Curves with Shadow/Highlight with a moderately strong Midtone Contrast. The former may look more natural, but the latter may offer more control.

4 If there is strong segmentation, or a clear need for confining contrast enhancement to the lighter or darker tones, consider making a luminosity mask (Channels palette) and applying either of the methods in 3 above. This may need to be done once for the lighter tones, then invert the selection and perform a second operation for the darker tones.

5 Consider running Unsharp Mask at a low percentage and high radius. Beware with all these steps of over-doing the enhancement, which is a particular danger when adding one after another.

6 An overall color balance if necessary, such as by using Photo Filter (*Image > Adjustments*), clicking on the color swatch, then clicking on the color in the image that you want to reverse, then adding 180º to the Hue.

7 Selective color correction if necessary, using Replace Color, possibly more than once for different colors. This is often needed because of excess color saturation in the highlights of a tonemapped HDR.

8 The usual artifact removal with the Spot Healing Brush tool or Clone Stamp tool.

Curves or Shadow/Highlight?

The two natural choices in Photoshop for finalizing contrast and brightness are Curves and Shadow/Highlight. Both work in very different ways — Curves traditional and global, Shadow/Highlight tonemapping and radius-based — and choosing between the two is not always easy. Much depends on the post-processing needs of the image, but personal taste comes into play. Here are the dialogue windows for each, separately applied to the same image. As I was aiming for the same general effect, the differences are subtle. Basic conclusions are: Adjustments in Curves are simple, with no local control, but tend to look more natural and photographic, while Shadow/Highlight tonemapping offers greater control but at the risk of looking more artificial. Images that have already been tonemapped quite aggressively because of their high range may do better under Curves.

Original

Curves

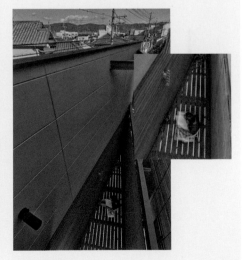

Shadow/Highlight

Color, contrast, and brightness

This is a fairly uncomplicated example of HDR tonemapping followed by basic post-processing. The subject is a detail of an old vaulted ceiling with decorative tiles, lit only from beneath — fluorescent strips in a recessed trough. In fact, this conforms to the first class of HDR scene shown on pages 30-33, a progressive brightening without strong luminosity edges, and so is quite straightforward to tonemap.

The tonemapped version having been processed in Photomatix. It is lacking somewhat in mid-to-large-scale contrast, and there is an overall greenish/yellowish tinge despite best attempts during shooting to match the fluorescent lights with the correct white balance setting.

There are many ways of adjusting color overall. My preferred method in a case like this is to sample the offending hue cast, then apply a filter of the opposite hue. To do this I open Photo Filter in Photoshop, click on the color swatch in the dialogue window, and then click on the pale tiles at the bottom of the image (which should be neutral and pale). This displays the color in the "Select filter color" window, with a hue angle of 46°. I then simply add 180 to this number, making it 226°, and click OK. I can then adjust the Density slider of this color filter to taste. Here I apply 50%.

Input Levels:

| 10 | 1.00 | 255 |

The first check is Levels for the black and white points. As often, the white point is fine, but the black point needs closing in a little. This darkens the image overall slightly.

Lightening, combined with an S-curve, produces this shape in Curves.

Next, a low intensity/high radius unsharp mask for further overall punch. I find that I often want to apply this filter to tonemapped images, as a corrective to the typical flattening of mid-scale contrast.

Last of all, a 100% magnification check across the image for dust shadows and other artifacts. The usual tools for dealing with these are the Clone Stamp Tool and Spot Healing Brush Tool. In this case, the image is clean and nothing needs to be done.

The final prepared image.

Tonemapping single shots

Tonemapping is not exclusive to HDR, just necessary for it.

The LDR Raw file as processed in Photoshop's Raw converter for best effect, attempting to retain the clouds without overly darkening the battleship. When the same Raw file is opened in Photomatix, a warning window appears, a reminder that this is not a real HDR operation.

As we've seen, the term covers a wide variety of software procedures, although nowadays most people understand it to involve local contrast enhancement. Photoshop's Shadow/Highlights is one of the best-known tonemapping operators for use on normal LDR images. Raw converters all include tonemapping capability, and this is particularly valuable because of the extra potential dynamic range in a 14-bit or 12-bit Raw image, over that in a camera-processed JPEG or TIFF. The HDR software we've been discussing has particularly powerful and sophisticated TMOs, which makes them especially well-suited to treating single images.

This is not, of course, a substitute for real HDR capture, generation and tonemapping. It makes most sense to use with Raw files because of the extra potential range they carry. I keep on repeating potential, because how much over standard they cover depends on the specific camera sensor and the way you exposed the shot. As discussed on page 15, the real limit to dynamic range in a single LDR image is the noise floor. Photoshop fails to recognize single images as objects for HDR generation, and while there is a workaround in the form of creating two versions from a single Raw first, one bright, one dark, then replacing the EXIF data, this is a great deal of trouble that can be bypassed completely by using either Photomatix, FDRTools or EasyHDR, which have no such limitation.

The only justification for processing a Raw file twice before combining into an HDR and tonemapping (which can be done in any HDR software, given that the EXIF data may need to be edited), is to take advantage of the recovery algorithms in the Raw converter that you normally use.

The tonemapping settings finally selected in Photomatix. The highest, most "photo-realistic" Light Smoothing setting is being used, because otherwise there would be haloing around the superstructure of the ship—and this is a complex outline that would be extremely difficult to deal with. The result will need adjustment to the dark-to-mid-tones, which are too low.

Final adjustments are made in Shadow/Highlights, applying fairly strong settings, especially to Midtone Contrast, although reducing Color Correction as the HDR tonemapping has already produced a very well-saturated result. Compare this result with the LDR image. A matter of taste, clearly, but to me the HDR tonemapped version is a considerable improvement on the LDR. The colors are richer without being over-saturated, the sky is good and strong, while the shadow details are opened up well, with good local contrast. The only problem is a slight haloing visible within the rigging on either side of the superstructure.

Post-processing begins with a Levels check. Although the black point is well-anchored, the white point needs to be closed in, and the gamma mid-point slider adjusted to lighten the mid-tones.

Tonemapping scans

As film, and in particular negative film, has a good dynamic range due to its non-linear response, it has the potential for pseduo-HDR tonemapping, provided that it is scanned appropriately.

◀ Scanning the negative

As the film stock was ISO 125 (Kodak Plus-X) and medium format (6 x 9cm), image quality is not an issue. There are two frames of the chosen scene, shot at one *f*stop apart, but the difficulty of registration dissuades me from scanning both to make use of the extra dynamic range. The less exposed negative (below) still has a very respectable range.

Tests performed by Kodak and others show that negative film is capable of 4 orders of magnitude. Practically speaking this means between 12 and 20 stops of range, which is very high, black-and-white negative more so than color negative. If you examine a negative under a loupe on the light box, this should come as no surprise, but anyone familiar with traditional darkroom printing knows just how difficult it is to extract even a part of the range that you can see in the negative and present it in a paper print.

The principle for generating HDR from a negative is to scan it at different exposures. How precisely this can be controlled depends on the scanner itself. And, as the scanner software applies curves to the scans to make them presentable, ideally we would want to invert

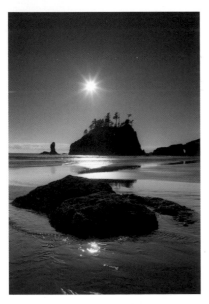
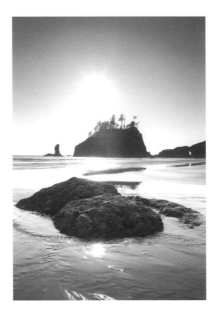
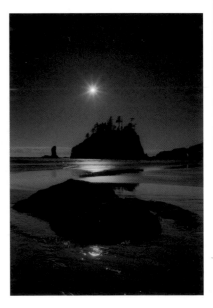

The negative is scanned three times in a Nikon Coolscan 8000 scanner, at (from left to right) average (visually determined), 2 stops over and 1.5 stops under. As this is a slide scanner, so the film physically moves in its holder, there is always a risk of misalignment. This was later checked in Photoshop and found to be within the tolerances of HDR software—a few pixels offset only.

the system response to get back to linear. Practically, however, this is not necessary, as HDR software such as Photomatix and FDRTools will simply estimate the response, or allow you to enter it manually. What matters most is to adjust the exposures of the set of scans so that they are about 2 stops apart. Using a Nikon Coolscan for this example, I adjusted the Analog Gain.

In a way similar to the set of three exposures in Thailand, with the sun setting behind a Buddha statue (page 70), the low dynamic range versions offer a choice of preserving highlight detail and transitions in the sky *or* the same in the shadows, but not both. HDR tonemapping is the ideal solution.

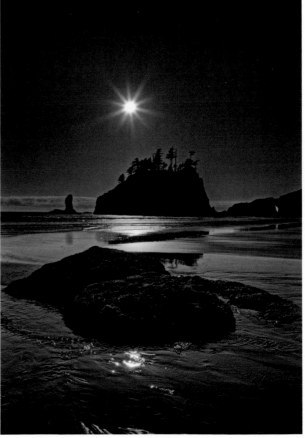

▼ Two versions of tonemapping, with Photomatix (left) and FDRTools. The differences are subtle, and reflect the different proprietary algorithms that each uses. As usual in HDR work, there is no objective "better." Both do an excellent job of opening up the shadows in the low foreground rock, but with a different visual feel.

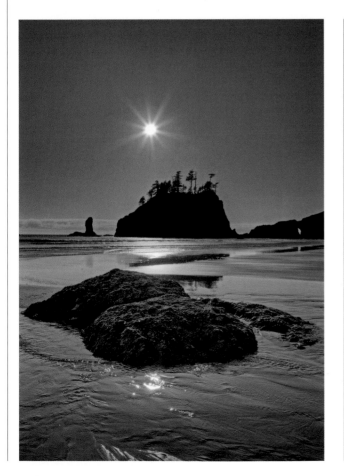

HDR **workflows**

One of the feelings you may have by now, if you've been reading this book all the way through from the beginning, is that there are just too many variables. You move one slider, and it affects another, or you move it knowing that tweaking another one will bring something back into line. This is made all the more complicated by the many different ways of changing things in the image. There are by now several consumer-level programs, and they all work differently — or rather, the things they have in common have to do with mathematics, not photography. In the end, most photographers who enter HDR will settle for just one program and set about learning that, becoming familiar with its particular ways. This makes life simpler. I've been using most of them, and can say quite honestly that they are all capable of producing good results, just not in the same way.

What follows is a look at workflow and at particular cases. The intention is not that you take one of these examples in all its detail and try to apply the same procedure to another image. Rather, it is to show the kind of decisions that can go into HDR and tonemapping. Where things go wrong, I show and tell. There are inevitably frustrations in any workflow, wondering why something is happening, or how to correct some image condition that you don't like. But overall, these procedures can be involving and interesting, with a lot of room for exercising skill and personal interpretation.

Think of tonemapping as the entire craft of photographic printing — a craft that had its last peak during the heyday of black-and-white photography. In fact, any sophisticated method of controlling the values of tone and color in an image is a form of tonemapping. As has been pointed out more than once, dodging and burning under the enlarger was one of the early forms of tonemapping, and the work of Ansel Adams is often quoted in this respect. This is more than just a pleasant analogy. One of the leading research groups in HDR and tonemapping, Reinhard et al., took Adams's Zone System as a starting point in their design. The Zone System, as Adams intended, married measurement with artistic judgment, and Reinhard realized that this is what a good tonemapping operator should do. Things have moved on in the last few years, with more and more photographic needs being catered for by the latest HDR software.

Workflows

It is important to devise an efficient workflow that suits your way of shooting and processing.

Because of the many possible variables — including file format, the need for corrections such as chromatic aberration, post-processing needs, and so on — settling on that workflow is not as easy as it might first appear.

Below is a summary of many of the possibilities — a variety of alternative workflows tailored for different stitching and HDR scenarios. These possibilities will be further explored later in the chapter.

Basic HDR workflow

Capture	Download & Save in folder as set	Generate HDR	Save as HDR	Tonemap (TMOs)	Save as TIFF/JPEG	Post Process	Final result as TIFF or JPEG
Raw *		Photomatrix		Photomatix		Photoshop	
		FDR Tools		FDR Tools		Lightroom	
JPEG		Photospere/ hdrgen	HDR	Photoshop	TIFF/JPEG	Aperture	TIFF/JPEG
		Photoshop		Easy HDR		LightZone	
TIFF		Easy HDR				DXO Optics	

Workflow variations (special needs/cases)

	Capture	Download & Save	Pre-process	Save	Generate	Result
1	Raw JPEG TIFF		DxO PT Lens LensFix (remove chromatic aberration)		–	–
2	Raw JPEG TIFF		Any Raw converter at neutral setting Nil Nil	TIFF	Photosphere/hdrgen Photosphere/hdrgen Photosphere/hdrgen	Flare removal
3	Raw JPEG TIFF		–		FDR tools	Full control over ghosting
4	Single image Raw JPEG TIFF		–		 Photomatix FDR Tools	Pseudo HDR
5	Single Raw	RAW	any Raw converter - Light - Dark		Photoshop Photosphere	Double processing of one Raw to take advantage of Raw convertor recovery a Pseudo HDR method.
5a	Single Raw	RAW	Any Raw converter -Light - EXIF renaminng utility -Dark - EXIF renaming utility		–	–
6	Single Raw	RAW	Any Raw converter		–	Making false extra light session to "expand" range of capture

HDR stitching: Direct HDR

Some stitching software now supports 32-bit HDR files, which makes for a huge improvement in the workflow, both in terms of speed and the amount of attention needed.

Images do not need to be opened during the process, and most of the workflow can be automated. The example used here is the same as before, also using Stitcher from Realviz. A warning: Stitching programs rely on the images being the same size, but pre-processing large HDR files in HDR software sometimes results in one or two images being out by a pixel or so. In this case they will probably be rejected by the stitcher, and will need, somewhat tediously, to be resized in Photoshop.

There are two basic alternatives to this direct stitching of HDR files, and example workflows follow on the next several pages. They are tonemapping first, then stitching regular 8-bit files, or tonemapping last, having stitched each exposure in the sequence separately. The advantages of this first method of the three are that it is the fastest, and automated right until the end, so that it needs little attention. The disadvantage is that any errors are hard to spot until the end, so any re-working means going back to the beginning.

The Raw images are selected in the database. As we can see, there are three sets each of 7 exposures.

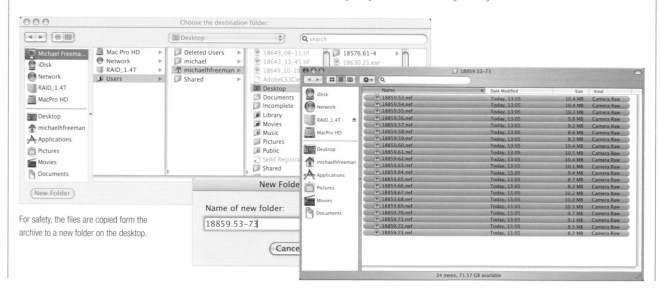

For safety, the files are copied form the archive to a new folder on the desktop.

Three new folders are created, for the left, middle and right sections of the panorama, and the files dragged into them.

The folder on the desktop now looks like this, with the three automatically processed HDR files at the bottom.

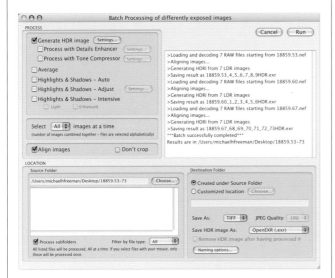

Photomatix can now be directed to process the three sets into an HDR file, using its Batch Processing option. Note that "Process subfolders" is checked, and the output set to EXR.

In Stitcher, the three images are selected and loaded. The focal length is confirmed (18mm is the 35mm efl of the actual focal length, 12mm on a APS-sensor Nikon).

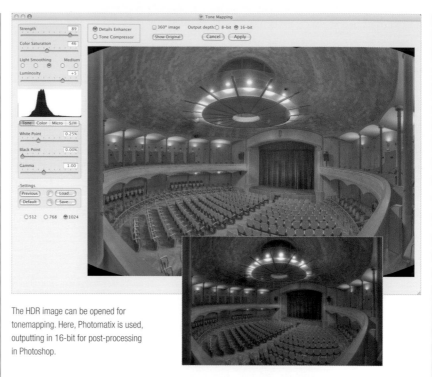

Using AutoStitch, the images are stitched without need for equalization or any further adjustment.

The HDR image can be opened for tonemapping. Here, Photomatix is used, outputting in 16-bit for post-processing in Photoshop.

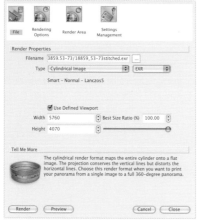

Post-processing includes cropping, an S-curve favoring the dark-to-mid-tones, and Shadow/Highlights in Photoshop.

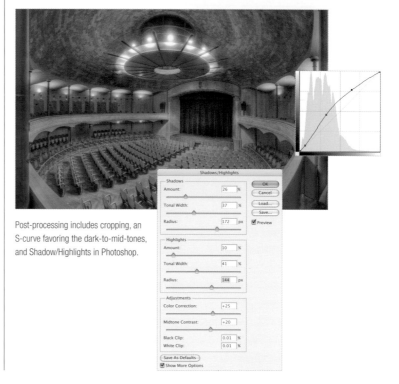

The image is cropped before rendering. The output is Cylindrical, which creates a usable flat projection of the wide-angle panorama, and EXR format.

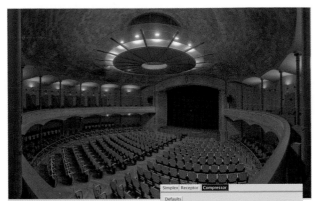

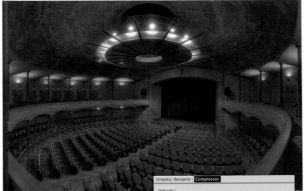

An alternative processing route is with FDRTools. The file created by Stitcher is opened directly for this default view and settings.

Compression is increased strongly, as the dynamic range is high, accompanied by some Contrast and Smoothing increase, and slight desaturation.

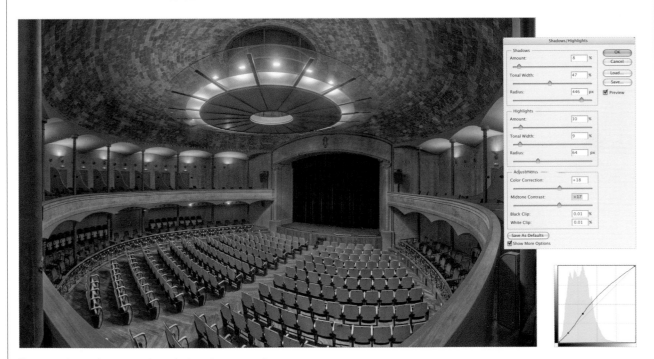

The same post-processing steps are taken as for the version tonemapped in Photomatix, but with much gentler settings in Shadow/Highlight.

HDR stitching: Tonemap first

With stitching software that does not support 32-bit HDR, there are essentially two alternatives: Either tonemap before stitching, as here, or stitch and then tonemap.

The advantages are that this gives maximum control over the images at an early stage, and it is faster and easier for images built up from a long capture range but a small number of frames to be stitched.

The same file preparation is used as for the previous, direct HDR stitching. The Raw files are copied to a new folder and divided into three groups, each for creating an HDR file. At this point, however, the three HDRs are opened and tonemapped before being loaded into Stitcher as TIFFs.

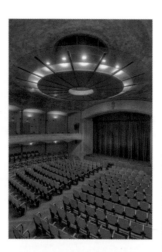

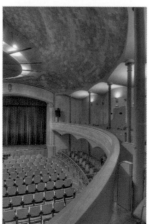

Beginning with the left part of the stitch, each of the groups of seven exposures are loaded and tonemapped in Photomatix. The settings worked out for the first are applied to the other two, on the assumption that the luminance is the same.

The three tonemapped TIFFs are loaded into Stitcher. *Stitch > Automatic stitch* is chosen, and the focal length set to 18mm, which is close enough for the stitcher to work on.

The stitched images are then equalized, a step that was unnecessary in the previous example of stitching HDR files.

HDR STITCHING: TONEMAP FIRST

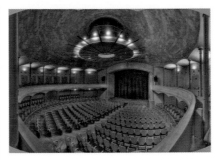

The equalized result. At this point, I notice a suspicious difference in brightness, but continue anyway.

The unsatisfactory result, due to brightness differences between the three images at the tonemapping stage. This requires going back to the beginning, and adjusting the tonemapping Luminosity settings. I do this with the left image open, while tonemapping the center and right frames one at a time, for a visual match.

The crop is chosen in the Render Area window.

On the now-correct, re-worked stitch, some geometry adjustments in Photoshop, using Warp to squeeze the center slightly and so make maximum use of the picture area (the cylindrical render typically created curved corners).

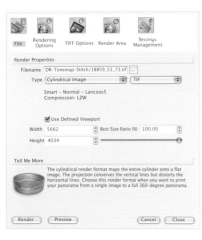

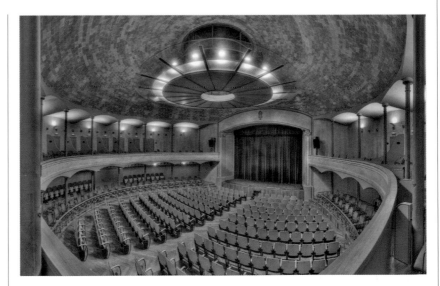

Summary of final render settings.

The final image. Compare with the results from the first stitching method.

HDR stitching: Tonemap last

The third stitching alternative is to tonemap last.

As we'll see, this method is the most fiddly and time-consuming, but for various reasons is currently the one that I use most. Its advantage is that it leaves the most uncertain part of the workflow—the tonemapping—to the end, allowing easy experimentation, such as switching to different tonemapping software. Its disadvantages are that the file preparation is time consuming, and mistakes are likely in the techniques used to "fool" the stitcher.

The principle is to stitch together the frames at each exposure setting, so that you essentially end up with a set of images to convert into HDR that resemble a normal HDR generating process. In other words, once the stitching is out of the way, you have a normal HDR workflow. The tricky part is to apply exactly the same stitching to each set of images. There are different ways of achieving this, but all require that the stitching software treats each set as if it were the first. The method I use here for "fooling" the stitcher is to name the files identically, then replace them set by set.

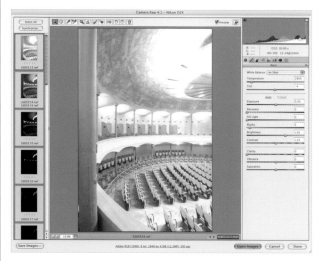

As Stitcher needs TIFFs rather than Raw files, all 21 images are processed through a Raw converter with no changes.

The files are grouped in a completely different way from the first two stitching methods. Instead of being grouped by frame-for-stitching, they are grouped by exposure. Seven folders are created, and the files dragged into their appropriate folders. I choose the exposure that will be easiest for the stitcher to stitch automatically, the second brightest. I then rename the files in all the other folders to match. This is rather time consuming.

Stitching begins with the second folder.

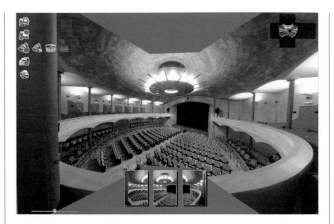

The three images from the second folder stitched...

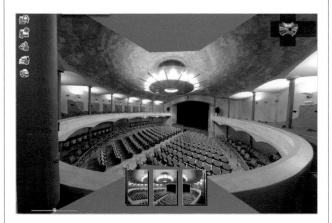

... then Equalized (click *Render > Equalize all images*).

Naming protocols are important. This first stitch is saved into a new subfolder for the set as "2." Confusion is a danger with this method, and replacing the wrong files means starting all over again. Note that for this reason I have made a copy of the entire folder before starting work.

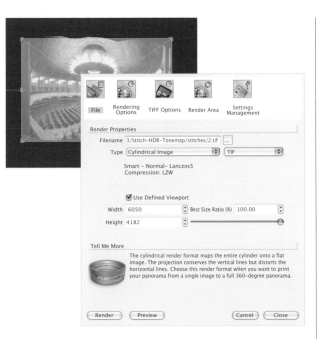

The settings and crop area for this first stitch. None of this will change for the remaining stitches.

When the stitching is complete (the TIFF appears in the subfolder "stitches"), the three files from the lightest set, numbered 1, are dragged into folder 2.

A warning pops up immediately. With Apply to all checked, Replace is clicked.

Immediately, another warning appears, this time from Stitcher. It wants to re-load the images, assuming they are identical because of the same filename. Yes is clicked.

The new, lighter images appear in the stitching window. They are Equalized.

The result of this stitch is saved as "1." The process is repeated for each folder. By the end, there are seven identically stitched images.

We can now begin the HDR workflow as if we were starting with freshly captured images. However, the EXIF metadata has been lost in the stitching, and the HDR software makes a wrong guess.

This is corrected manually. Always having the same exposure gap during shooting is a clear advantage—in my case always 2 stops.

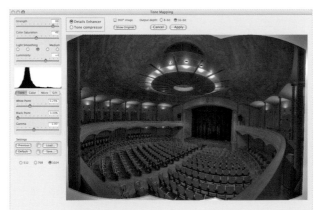

The HDR file is then tonemapped as normal.

For some reason, the geometry is more skewed than in the other two stitching methods, but this would need to be adjusted in any case.

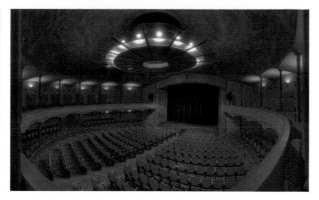

The tonemapped TIFF, needing post-processing.

A combination of Distort and Warp is used, in Photoshop.

That process takes the form of a curve that both lightens the mid-to-dark tones while increasing contrast slightly.

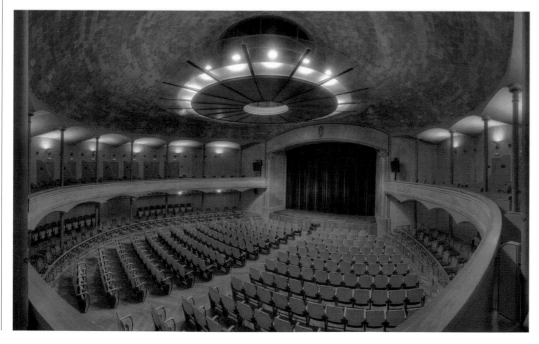

The final result. Compare this with the other methods.

Case study: **Church**

The standard test image for HDR research remains the fisheye shot of Stanford Memorial Church taken by Paul Debevec.

Churches remain a special yet familiar case, and so appropriate for the first of our case studies. The conditions are a large, poorly and unevenly lit interior containing a wealth of interesting detail, and small windows typically fitted with stained glass that we also want to see in their full glory. In fact, as we'll see in later case studies, this is a challenge but by no means the worst for HDR tonemapping. The key thing to remember is that we will need to open up a lot of mid-shadow detail and enhance Microcontrast to bring out the wealth of detail in tiles, windows and statuary. Apart from that, the color and tone of the stained-glass windows has to be held, but as tonemapping tends to exaggerate highlight color saturation anyway, this is unlikely to be difficult.

There are five source images spaced two stops apart. For comparison, we'll process them first in Phototmatix, then in FDRTools.

The five TIFFs are loaded into Photomatix.

No movement, so no need for ghosting correction, just alignment needed for safety.

The software estimates a dynamic range of 4,000:1.

The exposure values are checked — two stops apart.

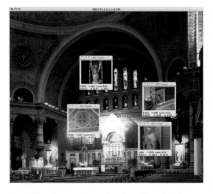

The HDR as it appears in preview form. Four of the key magnified views are superimposed. Before tonemapping begins, it's as well to have a good idea of what we need to achieve in the key areas (spotlit regions, deep shadows, and stained glass).

The tonemapping as it appears at the default settings.

Begin with the middle Light Smoothing setting, and set Strength to the maximum to ensure that the spotlit areas will be pulled into range.

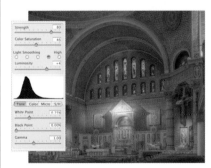

The range is quite high, so a slight increase to Strength.

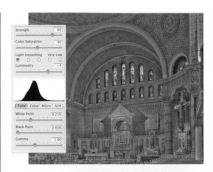

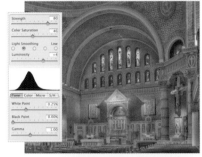

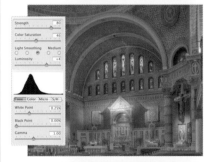

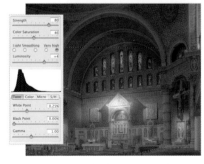

A quick flick through the Light Smoothing alternatives. Because there are no significant luminosity edges and no significant segmentation, coupled with the already slightly unfamiliar distribution of lighting inside the church, it is possible to choose a lower Light Smoothing setting than usual. The third (Medium) shows no haloing or artificiality, and maybe even the second might work. I will do both.

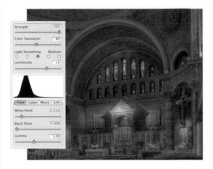

As a further precaution against losing detail in the spotlit areas and the stained glass windows, the white point is dragged back from its default clipping.

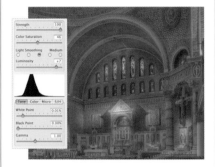

Because this darkens the image overall slightly, Luminosity is adjusted upwards.

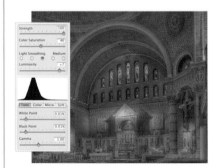

I feel that a slightly closed in black point would help the naturalness and make the darkest parts pure black.

Moving on to Color, the highlights are desaturated slightly and the shadow saturation increased slightly. This is in anticipation of the usual excess highlight saturation from a high Strength setting.

Moving on to fine-scale contrast, I choose a key area to examine, and raise both sliders. The effect will be crisp but not excessively so. I keep an eye out for any hint of noise.

Having fine-tuned the settings, I save them for future reference. The image is then processed and saved.

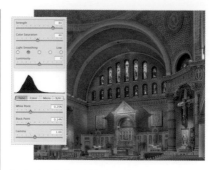

I go back to the lower Light Smoothing setting. Ordinarily, with a more normal and familiar scene, I would never consider this because of its artificiality and strong haloing. However, as we saw at the beginning, the lighting conditions here are such that it shows none of these ills, while it opens up local contrast in the mid-to-dark tones very well. I think this may be a better route than before. Luminosity is at default, with Strength raised slightly to 80, and the black point closed in for a few strong blacks.

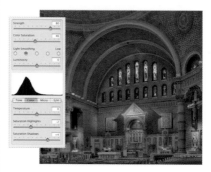

Saturation in the highlights and shadows is set as for the earlier tonemapping.

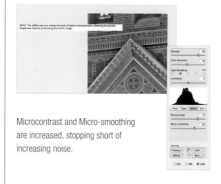

Microcontrast and Micro-smoothing are increased, stopping short of increasing noise.

These settings are now saved as version 2, the image processed and also saved.

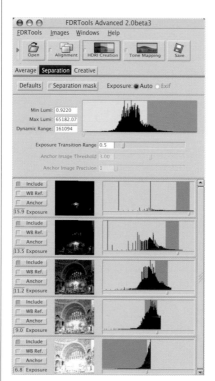

Moving on to FDRTools, the source images are loaded. The Separation window shows which parts of the tonal range of which image are being used for the HDR assembly. There's no reason to adjust any of these.

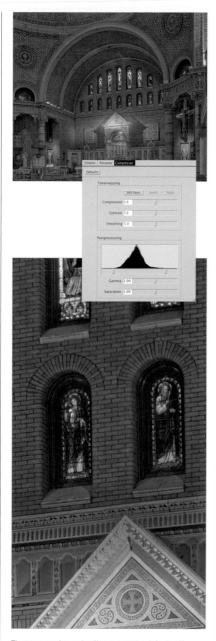

The tonemapping as it will appear at the default mid-settings. I choose a 100% Preview window that covers the areas I'm most concerned about.

Beginning with the Compression setting, I take it right up to the maximum of 10 to gauge its scale of effect before settling for a setting of 8. This increases local contrast, but flattens the contrast on a larger scale. The Contrast slider will adjust that.

Taking the Contrast slider up to 7.5 improves the mid-scale contrast slightly, and taking the Smoothing slider up to 8 significantly improves this and large-scale contrast.

The image feels as if it could do with a little more color saturation. This is increased from 1 to 1.20.

The image is processed and saved.

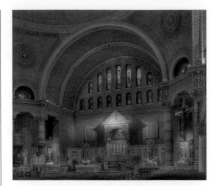

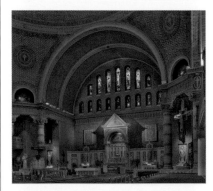

The three differently-tonemapped versions before post-processing. As judged at this stage, the second version in Photomatix, with the lower Light Smoothing setting, is much better than the first. These lower settings open up local contrast strongly, and while they normally exhibit haloing, tone reversals and artificiality, in this case the scene masks these. As for the FDRTools, I now think that I should have used a lower Compression setting, as the structure above the altar looks weak and lacking in mid-scale contrast. We'll see finally when each has been post-processed as well as possible.

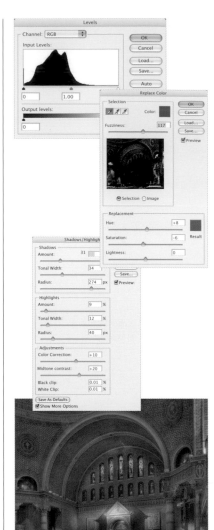

The first Photomatix version needs the most work: a Levels check, selective color replacement of the 'hot' tiles (perhaps I should not have raised the color saturation of the shadows), and significant tonemapping in Shadow/Highlight.

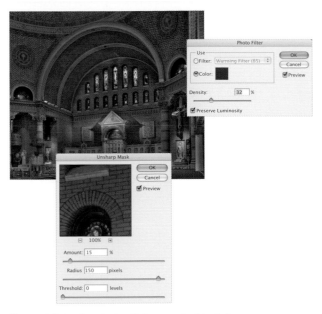

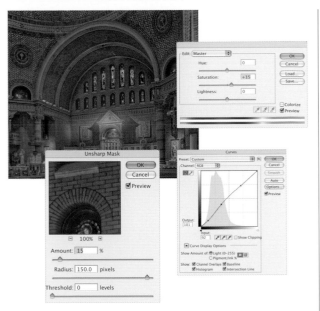

The second Photomatix version benefits from some low intensity/large radius unsharp masking for punch, and a blue-ish filter.

For the FDRTools version, it still needs more color saturation (this could ideally have ben done within the application), and an increase in mid-tone contrast, which is achieved by a gentle curve and by similar usharp mask settings as those used on the second Photomatix version.

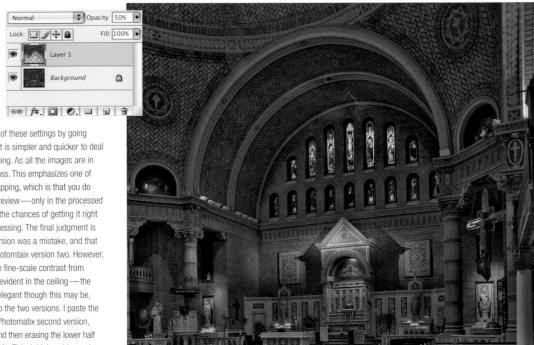

Of course, I could refine all of these settings by going back to the beginning, but it is simpler and quicker to deal with it now, in post-processing. As all the images are in 16-bit, there is no quality loss. This emphasizes one of the realities of HDR tonemapping, which is that you do not see the final result in preview—only in the processed image—and this reduces the chances of getting it right at one go. Hence post-processing. The final judgment is that the first Photomatix version was a mistake, and that for overall effect I prefer Photomtaix version two. However, I prefer the treatment of the fine-scale contrast from FDRTools, and this is most evident in the ceiling—the upper half of the image. Inelegant though this may be, my final decision is to comp the two versions. I paste the FDRTools version over the Photomatix second version, reduce its opacity to 50% and then erasing the lower half with a large brush set to 50%. This, I think, achieves the best of both worlds.

Case study: **HDR portrait**

This portrait of Chinese artist Yue Minjun in his studio needed a sense of the strong contrast caused by the intense winter sunshine streaming through the window, but preserving the highlights was crucial too.

What is interesting here is that I would never have attempted this shot—looking through from shadow to strong sunlight—without HDR. The obvious solutions in normal LDR shooting would be to add foreground lighting, or ask the artist to move, or perhaps soften the sunlight with scrim, or even wait for the light to change. None of these would have appealed to me, and here was a case where I liked the lighting effect with its intense contrast, and for once felt able to capture it. From the point of view of reportage, nothing was moved. This was exactly how the artist worked. In this kind of portraiture it is usual to move the subject around to suit the shot, and here I was happy not to have to do that.

Because I did not want to open up the shadow areas fully, I restricted the range of the shot sequence to six stops. This was also partly because of the length of the exposure—I needed good depth of field, so set an aperture of ƒ/20, but I also needed the artist to hold still, as the exposure times for this sequence of 4 were 1/30, 1/10, 1/4 and 1 second. A further exposure at 4 seconds would have been too long. Even so, I expected that there might be some movement between frames that could produce ghosting. This indeed was the case. Not only did FDRTools' strong HDR generation features offer good control over this, but did so by default.

The Raw source images are first selected and loaded.
FDRTools automatically creates the HDR.

The Navigator window shows a preview of either the uncompressed HDR or tonemapped image. On opening, I choose the default tonemapped view. I also check the EXIF button rather than the default Auto; there is a slight difference and the EXIF is more accurate.

I go straight to Tone Mapping and choose the Compressor method, which is FDRTools' term for its local operator. Even at default, this is already considerably better than the Simplex method.

I adjust the settings for high local contrast, particularly in the shadowed area. This means high Compression (9.0), high Contrast (8.0) and low Smoothing (3.0), this last effectively strengthening the effect of the contrast slider. These settings are about as high as I can go without incurring bad noise on the artist's sweater. Then, I increase Saturation for stronger pinks in the painting.

A highlight (see below) in 100% preview mode.

I notice that the highlight on the brass figure appears to be clipped. I correct this by moving the White Point slider to the right. This darkens the image more than I would like, so I adjust by lowering the Gamma a little, which flattens the appearance more than I like. Closing in the Black Point slider slightly helps a little, but the result is that the image will need post-processing in Photoshop.

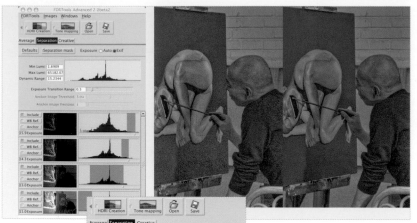

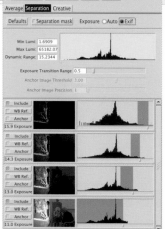

With the tonemapping done for the time being, I go back to HDRI Creation. Of the three methods of HDR generation, I select Separation, which allows close control over which image contributes which tones to the final mix. As it turns out, even though the artist moved between frames, the default has correctly chosen the bottom frame to dominate. As an experiment, dragging the Intensity Separation Slider to the left forces the third frame to dominate—on the left in this comparison. I revert and use the default.

To improve overall contrast in the shadow-to-mid-tones, I apply a curve, anchoring the highlights at the top.

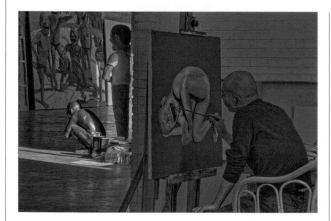

The image is saved as a 16-bit TIFF, using the option to open directly in Photoshop CS3. As anticipated, it is way too flat overall.

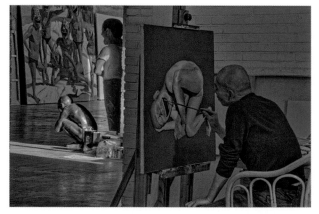

This is certainly an improvement, but there remains a flatness in the mid-scale contrast, and a slightly artificial feel. On this latter point, all the detail is visible, but it looks, to my eye, not quite like a photograph. The tonemapping controls are unlikely to be able to improve on these two faults, and so I turn to a primitive and not very elegant solution—a partial blend with one of the original source images.

As the problems are located in the right-hand section of the image, the lightest of the source images is opened in an image-editing program (here DxO) and enhanced for this area alone.

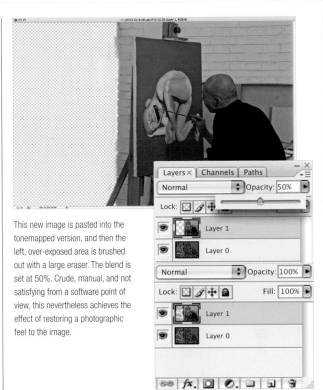

This new image is pasted into the tonemapped version, and then the left, over-exposed area is brushed out with a large eraser. The blend is set at 50%. Crude, manual, and not satisfying from a software point of view, this nevertheless achieves the effect of restoring a photographic feel to the image.

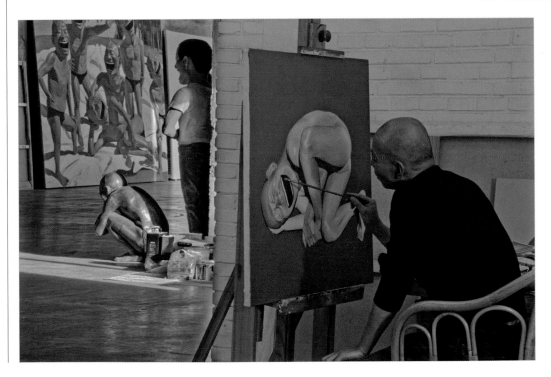

The final result, to my mind a good demonstration of how HDR can have a valid role in making photography possible in situations that would otherwise not have been tackled. Clearly, a large amount of work went into this image on the computer, but the subject, setting, and treatment are all natural.

Case study: **Pre-processing source**

This wide-angle shot, from the floor of the dome in the heart of the Museum of American History in Washington DC, has a high dynamic range due to the window at the apex of the dome.

Aided only slightly by floor-level lighting and higher spots, the window is essentially the light source — always the greatest challenge to HDR tonemapping. I shot six frames spaced two stops apart, starting with the darkest exposure. At the time it seemed as if the lightest exposure was full, but later, I wished I had added another to show detail in the elephant's underside. I also saw when examining the source files that dust specks were contributing flare polygons. I decided to add artificially another exposure, also to retouch the flare polygons before tonemapping, and for good measure to run flare removal when creating the HDR file.

Fooling the software into thinking that there is another, lighter exposure, is recommended only in emergencies, and you might think it is a waste of time, given that the software can read all the exposure information from the initial Raw file. The main limit to the dynamic range of an LDR file is the noise floor, located in the deep shadow areas, but modern Raw converters bring their own algorithms to bear in order to recover shadow detail and remove noise. This is, in a sense, false information because it benefits from processing, but it works to an extent. As for the flare, because Hdrgen and Photosphere are at this time the only software to attempt its removal, it would be necessary to put fake exposure information into the new image's EXIF data.

Creating a new image artificially means converting the 6 existing Raw files into TIFFs, and for this, DxO is used, with all lighting controls turned off, but the grey dropper used on all images to set a point in the ceiling to neutral.

These are processed and converted into TIFFs.

Next, the lightest image is loaded into DxO a second time. The exposure adjustment slider is set to an additional 2 stops.

At 100% magnification, the shadow areas are examined for noise. The default for the DxO converter has already performed good noise reduction, but for this new image the levels are increased manually.

This new, lighter version is then processed.

The file folder now looks like this, with the six original Raw images and seven new TIFFs.

Viewing the EXIF data for the new file, using EXIFutils (a command line program), the shutter speed is still set at 30 seconds, exactly the same as the file from which it was created.

Using the instruction -a exp-time=120, the shutter speed EXIF information is changed to that of a 2 minute exposure. This will fool the HDR generator.

```
Last Login: Sat Jul 14 14:18:56 on ttyp1
Welcome to Darwin!
You have new mail.
Michael-Freemans-Power-MacPro:~michaelhfreeman$ hdrgen -o NatHist.exr -f /Volu
mes/RAID_1.4T/STORIES/PHOTOGRAPHIC/PHOTOGRAPHIC_EDIT/HDR/TEST_IMAGES/NaturalHist
ory/tiffs/18678.[1-7].tif
```

As the dynamic range is high, we know that it will probably need a high Strength setting. This darkens the image somewhat, and to compensate for this, the Luminosity is increased.

Still in Terminal, but using another command line program, Hdrgen, the now seven images are combined into an EXR file, using the instruction *-f* to perform flare removal. The process takes just 15 seconds.

The newly created HDR file is now opened in Photoshop, and the brightness slider adjusted to show the flare polygons at their clearest. The clone tool is used to darken these blotches so that they become unnoticeable. The retouched image is saved back as a 32-bit EXR file.

Next, the Light Smoothing setting has to be chosen. The default is fine, but as usual, it is always worth checking to see if a lower setting is possible. The brightening, opening up of shadow detail and improvement of contrast have to be weighted against increased halos and an artificial appearance. Because there are no very obvious large luminosity edges, it is judged that the middle setting is possible. There is some haloing above the elephant's trunk, but visually this is confused a little with the rim of the arch behind the animal's head.

Moving to Photomatix, the image is opened for tonemapping at the default settings.

The black and white points are closed in slightly to strengthen the darkest shadows and brightest highlights.

NOTE: The 100% crop only shows the level of details enhancements. Showing the correct brightness requires processing the entire image.

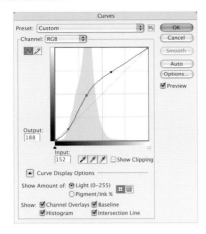

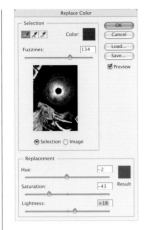

A magnified check on the elephant reveals no visible noise, allowing an increase in Microcontrast (which tends to increase noise as a by-product of improving fine-scale contrast), with an accompanying increase in Micro-smoothing.

The principal post-processing operation is to lighten the dark-to-mid-tones while holding down the low shadows, and for this, an S-curve that favors the lower tones.

Also in post-processing, the immediate surround of the circular window in the dome has acquired a strange ochre tinge, and this is altered and lightened using Replace Color. As this operation takes in some of the elephant also, the History Brush is used after this to restore all except the centre of the image.

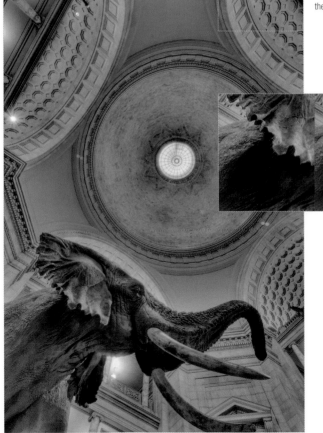

Although there is no obvious noise in the shadows, Shadow Smoothing is added in order to play safe and also to darken them. The tonemapping settings thus far have done such a good job on opening up the details here that we need to knock the deepest ones back for realism.

The final result, with rich detail in the shadow areas. For comparison, the close-up detail shows the same area under the ear of the elephant, on the left from an HDR built from the six original source images, on the right from the seven source images that include the newly created one. The right-hand version clearly has more shadow detail.

Case study: **Sky and shade**

A sharp sky boundary and a delicately toned sky create a kind of image that needs special care in the tonemapping.

Even when it is possible to get close to the final result with tonemapping, some post-processing is always necessary. In this case, a restaurant terrace in Beijing overlooking the former Imperial Archives, contrast and color balance were always likely to be issues under a clear winter sun in the late afternoon.

In preparation, I wanted an on-screen reminder of how key parts of the scene should look. For this, the small Photomatix preview window is ideal. I sampled 10 parts that I thought might be critical.

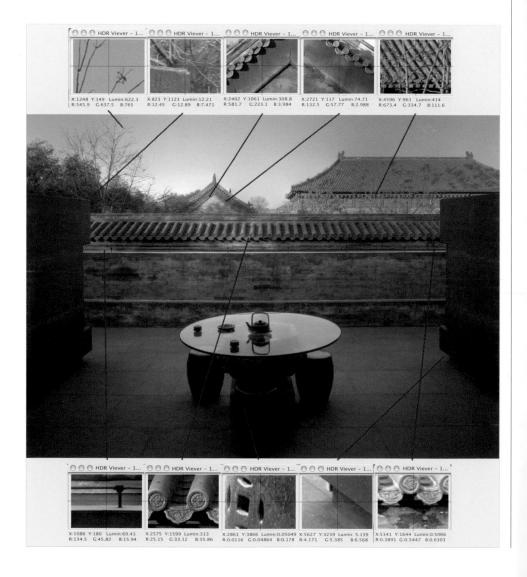

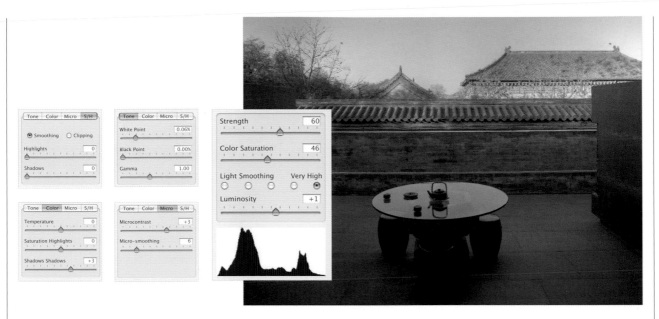

Using Photomatix, the chief precaution was to avoid haloing. This meant choosing the far right Light Smoothing setting and reducing the Strength. Color Balance was left alone, as this would have to be done selectively in post-processing. Microcontrast was increased to capture fine detail in the roof tiles in particular.

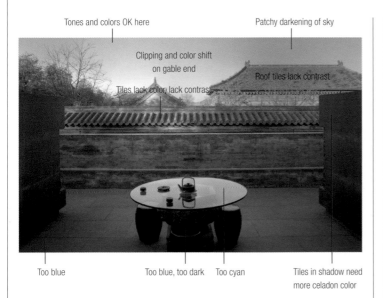

Tones and colors OK here
Patchy darkening of sky
Clipping and color shift on gable end
Roof tiles lack contrast
Tiles lack color lack contrast
Too blue
Too blue, too dark Too cyan
Tiles in shadow need more celadon color

The tonemapped image is opened in Photoshop and examined. There are several things that need to be done, as this annotated view shows. Even with Light Smoothing set to the far right, the main problem is the unevenness of the sky. There a large patch of darkening on the right, and it extends over the tiled roof, contributing to the lack of contrast there also. Correcting this manually, by brushing in a large area in Quick Mask, would be difficult. The best solution seems to be to make a second tonemapped version aimed just at even sky tones and then combine this selectively with the first image.

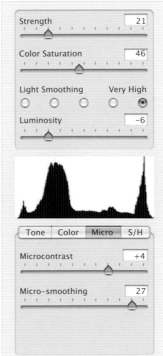

Accordingly, the new tonemapping settings are a much reduced Strength, lowered Luminosity, heightened Microcontrast (which darkens a little) and heightened Micro-smoothing (helps even out tone).

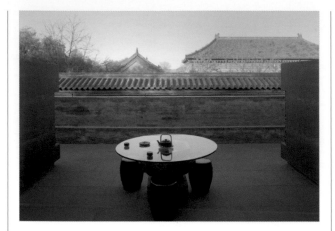

Although the sunlit areas in this second version are now too light, it no longer suffers from patchy darkening, while the tiles have better contrast and even the gable end has less clipping. Using Curves to darken the image overall improves tone and color saturation in the sky and roof.

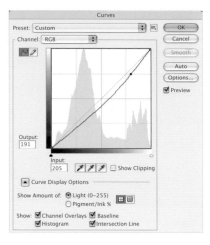

The first image is pasted on top of the second, and the sky and roof area selectively erased with a large, soft brush. The image is flattened and saved as version 3.

Hue:
-4
Saturation:
-8
Lightness:
unchanged

Hue:
+4
Saturation:
-1
Lightness:
unchanged

Hue:
+14
Saturation:
+15
Lightness:
0

Hue:
unchanged
Saturation:
-64
Lightness:
unchanged

Hue:
+7
Saturation:
unchanged
Lightness:
unchanged

Now a series of detailed color corrections using Replace Color: Shift the yellow clipping on the gable end towards orange and desaturate slightly, shift the salmon pink tendency of the roof tiles towards orange, increase the saturation of the green tiles, and shift them more towards celadon, strongly reduce the blue in the deepest shadows (but leave the lighter shadows to reflect the sky realistically), shift the label color away from cyan toward blue.

Finally, an overall improvement of local contrast with the Unsharp Mask set at 20% and a radius of 120 pixels.

The final image.

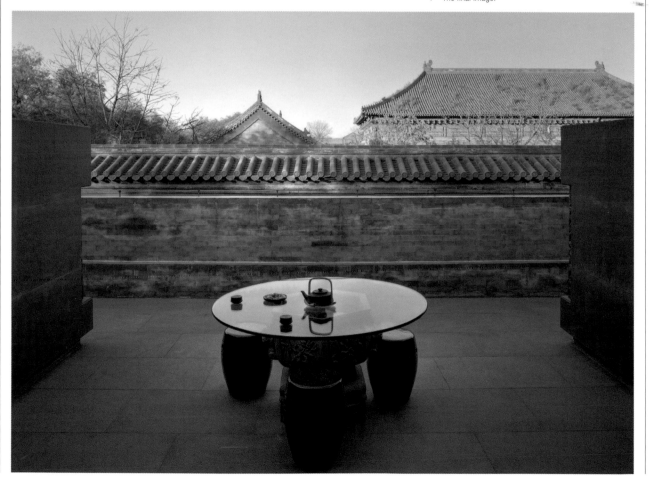

Case study: **City lights**

The view of central Tokyo that appeared earlier (pages 30-33) was the low dynamic range version, but here, from a sequence of just 3 frames, we can use HDR tonemapping to open up the many shadows.

This time we use this source we also introduce a workflow variation, because one of the issues with a wide-angle view containing many very bright areas contrasting with a dark surround is chromatic aberration. DxO Optics Pro is an image optimizing application for photographers with the unique feature that it automatically corrects distortions and aberrations. It does this by means of carefully constructed lens-plus-camera profiles that the company makes for most well-known brands and combinations. This is particularly useful with modern large-range zoom lenses, which tend to have higher distortions and chromatic aberration than traditional primes. One feature of HDR tonemapping, as we saw on page 65, is the tendency towards excess color saturation in bright areas and close to sharp luminosity edges — exactly the conditions in which chromatic aberration is prominent. The result, if uncorrected, is exaggerated color aberration fringes. This makes preprocessing images with DxO a valuable option, at the minor cost of not creating the HDR file directly from Raw.

Load the source images into DxO, go to Enhance and select all. In the settings, check Distortion, Sharpness, but disable (uncheck) DxO Noise, DxO Color, and DxO Lighting. We do not want to make any brightness adjustments when creating the TIFFs.

In this particular case, the White Balance was wrongly set to Cloudy during shooting, so this is the point at which to make a color temperature correction. Here, Daylight (meaning sunlight) is selected, despite the night time scene, and to verify the change the viewing option of Before and After is selected.

Move on to Process, and set the output for TIFF, saving them into a new folder. Note that 8-bit TIFF is checked — there is no advantage in the extra bit-depth from 16-bit when constructing an HDR, as the sequence spans the entire dynamic range anyway. Start the processing.

In Photomatix, go to *HDR > Generate* and select the newly processed TIFFs.

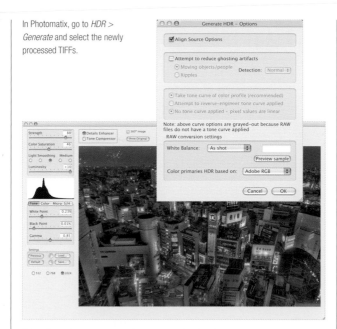

Adjust the settings and tonemap. The range in this shot is high, with strong segmentation in the form of the window frame looking out to a sunlit view. This calls for halo control, in the form of a reduced Strength, the fourth Light Smoothing setting, high Luminosity and some adjustment to Smoothing/Highlights to improve the highlight contrast in the view through the window. The image is saved in 16-bit for further post-processing.

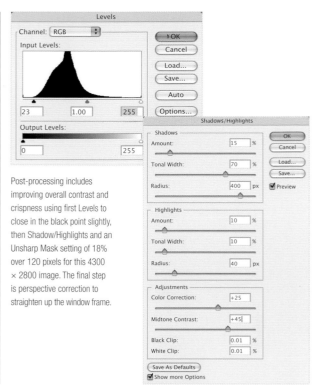

Post-processing includes improving overall contrast and crispness using first Levels to close in the black point slightly, then Shadow/Highlights and an Unsharp Mask setting of 18% over 120 pixels for this 4300 × 2800 image. The final step is perspective correction to straighten up the window frame.

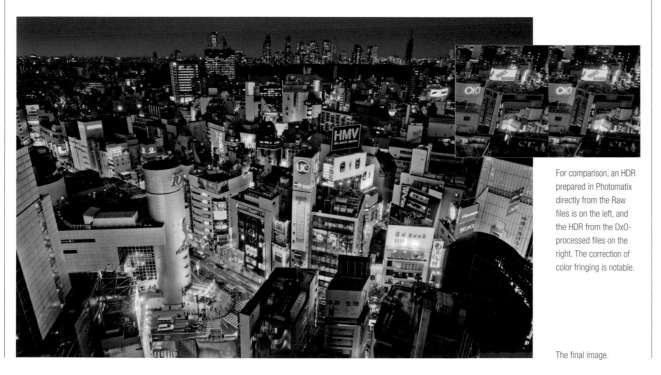

For comparison, an HDR prepared in Photomatix directly from the Raw files is on the left, and the HDR from the DxO-processed files on the right. The correction of color fringing is notable.

The final image.

Case study: **Delicate highlights**

The still-life subject here is a carefully chosen and placed white stone in a Japanese tea room in Tokyo.

The attraction of the shot at the time was the way that the dappled light through the window fell across both the smooth white surface of the stone and on the chiselled pattern of the slate shelf. One potential problem was that, in the course of a busy shooting schedule, I forgot to cover a full range of exposures. This meant that the lightest frame was still not fully exposed for the darkest shadows, although I did not in any case want to open up these shadows (I wanted to maintain strong contrast).

As usual, the first step is to analyze the range of exposures and the subject in order to prepare for tonemapping. The conclusions reached:

1 The key quality is the delicate dappling on the brightest part of the stone. Essential to avoid any clipping and to keep smooth gradients. Potential problem is pink in the highlights (a common feature in digital capture, as the red channel tends to preserve detail further into the highlights than the green and blue channels).

2 Need strong contrast in the middle range to emphasize the dappling. This could potentially conflict with point 1. Will probably call for post-processing.

3 Lightest exposure not light enough, so expect noise problems in the dark shadows. Will need to consider smoothing operations during tonemapping, perhaps black clipping, and cautious use of Microcontrast enhancement.

4 The dynamic range is not huge, and while there are two strong luminosity edges (top of stone, and its shadow), these are not likely to cause major problems – dappling on the upper edge of the stone should help to mask haloing, while the shadow edge can accept some haloing without looking strange, because shadows are not generally judged closely for realism.

With these points in mind, the procedure begins with generating the HDR from the three frames and, saving it as an EXR file.

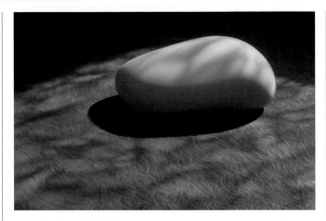

As a test, knowing how important the highlights will be, the image is tonemapped using Photoshop's Highlight Compression method. While this algorithm is hardly ever acceptable, in this case it gives a useful and surprisingly good rendering of the highlights. The smoothness is something to aim for when we use Photomatix.

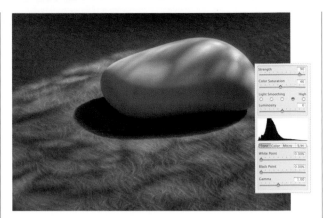

With the white point set back to 0, the other action we can take to preserve the highlights is to increase the strength of the compression and local contrast. This darkens the image and enhances the contrast of the dappling. The general over-darkening will be difficult to deal with within the tonemapping, but post-processing can take care of this.

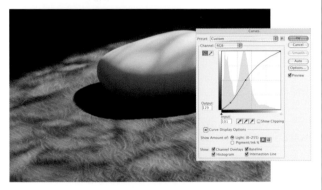

In fact, applying an S-curve biased to the mid-tones turns this into an acceptable image.

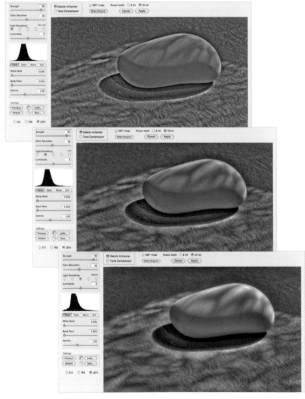

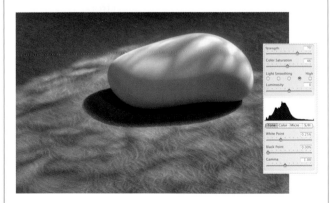

The default view in Photomatix Details Enhancer. The highlights are obviously blown, the reason for this being the default white point setting, which deliberately clips slightly (by a quarter of a percent).

At this point, we check the Light Smoothing options. Normally, anything below (to the left of) the default is too artificial to be worth considering, but in this case, the middle setting has useful possibilities in the way it opens up the mid-shadows and, above all, strengthens the dappling. But it calls for further work to improve naturalness.

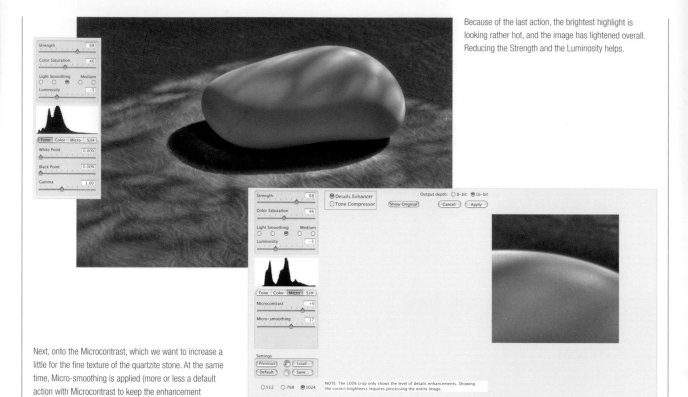

Because of the last action, the brightest highlight is looking rather hot, and the image has lightened overall. Reducing the Strength and the Luminosity helps.

Next, onto the Microcontrast, which we want to increase a little for the fine texture of the quartzite stone. At the same time, Micro-smoothing is applied (more or less a default action with Microcontrast to keep the enhancement natural-looking). This is judged with a 100% preview.

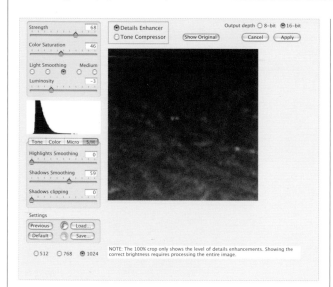

Next, an examination of the background shadow areas for noise. It was expected, and indeed is present. It can be obscured by darkening, as I want the shadows deep in any case, but a better solution may be as follows...

...Shadow Smoothing is designed just for this, and gently darkens and obscures the noise.

A small final touch is to remove any hint of pink from the brightest highlight (see analysis 1 on page 150) by reducing the output in the red channel by 3 levels at the top end.

Back out to a full view, the Shadow Smoothing needs fine-tuning, high enough to darken well, but not so high as to filter the lighter shadow near the edge. Overall, of course, the image appears rather flat, meaning insufficient mid-scale contrast, but a post-processing S-curve should take care of this.

In Photoshop, an S-curve similar to that above is applied to bring back mid-scale ocntrast while holding the shadows down.

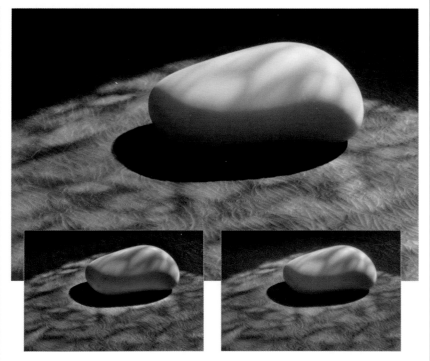

The result, with, for comparison, the Photoshop Highlight Compression method (inset left), and another Photomatix version (inset right) with Light Smoothing set to the more natural level 4 (High). Yes, there is some haloing, but in my judgement at least, this is not objectionable — in fact it is helpful in accentuating edge contrast and making the shadow under the stone interesting. These are, however, matters of taste.

Case study: **Strong segmentation**

Images that have strong segments—sharply enclosed areas of very different luminance—are of course prone to haloing.

Their strong luminosity edges make this inevitable. But in addition they also have a special need, which is that the entire area inside them appears to need a special treatment. The temptation, and almost the ideal, is to somehow select them and work on them individually. Indeed, quite often, out of failure, that is what happens in post-processing. The reality is that extreme segmentation combined with extreme contrast, as in this view looking out through the window of a Japanese home onto cherry blossoms, asks too much of the current generation of HDR tonemapping software.

If the software were somehoww able to recognize such a segment or region accurately and efficiently, and then treat the inside and the outside differently, scenes like this would be easier to process. As things stand at the moment, this kind of scene is a challenge. I should add, or rather repeat as I already mentioned it on pages 30-33, that there is a perceptual issue which adds to the problem. We are simply not accustomed to seeing photographs that show a bright exterior and a dim interior sharing similar tonal values and local contrast. In other words, however well you process the image, it is unlikely to look completely natural. The software used here is FDRTools, and it does a surprisingly good job with an extreme situation and some shooting errors.

The rendered wall and the cherry tree in flower are both very traditional Japanese elements, and both are delicate in color, which we want to retain.

Because flare is evident in the sequence of exposures, and entirely expected, given that the interior is dark and unlit, I decide to generate the HDR in Photosphere with flare removal checked. Photosphere is also a browser that supports 32-bit files.

The preview window in Photosphere reveals that there is still some flare, but more important, there are flare polygons from dust particles on the lens. Even though the focal length was medium long at 90mm efl, the lens was stopped right down to ƒ32, so I should have anticipated this and checked the lens surfaces at the time of shooting.

I can see that there is keystoning distortion, caused by the angle of shooting needed to frame the tree exactly. This is corrected in Photoshop's Lens Correction.

This suggests a good case for doing image-editing before the HDR stage. Several Photoshop tools are available, among them the Clone Stamp, although unfortunately not the Spot Healing Brush, which I would have preferred. Nevertheless, about 10 minutes' of work takes care of the more egregious flare artifacts.

Next, Shadow/Highlight is applied at moderately strong settings, in order to lighten the interior wall and to increase local contrast within the window frame.

Using FDRTools, the HDR file is opened and tonemapped. The settings, increased for Compression and Contrast, reduced for Smoothing, were selected by trial and error. Globally, the image is too dark at these settings, so Gamma is lowered. To enhance the pink of the cherry blossoms, color saturation is increased (the color will be fine-tuned in post-processing in Photoshop). Note that there is no evidence of flare, which is a pleasant surprise.

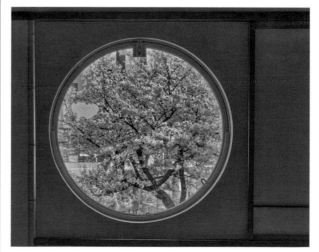

The final result. Some additional fine color adjustment was made to reduce some small areas of excess color saturation, but the basic color of the cherry blossoms was left alone, as it needs to remain gentle and subtle.

Glossary

Aberration The flaws in a lens that distort, however slightly, the image.

Aperture The opening behind the camera lens through which light passes on its way to the CCD.

Artifact A flaw in a digital image.

Backlighting The result of shooting with a light source, natural or artificial, behind the subject to create a silhouette or rim-lighting effect.

Banding An artifact of color graduation in computer imaging, when graduated colors break into larger blocks of a single color, reducing the "smooth" look of a proper graduation.

Bit (binary digit) The smallest data unit of binary computing, being a single 1 or 0. Eight bits make up one byte.

Bit-depth The number of bits of color data for each pixel in a digital image. A photographic-quality image needs 8 bits for each of the red, green, and blue RGB color channels, making an overall bit-depth of 24.

Bracketing A method of ensuring a correctly exposed photograph by taking three shots: one with the supposed correct exposure, one slightly underexposed, and one slightly overexposed.

Brightness The level of light intensity. One of the three dimensions of color in the HSB color system.

Buffer Temporary storage space in a digital camera where a sequence of shots, taken in rapid succession, can be held before transfer to the memory card.

Calibration The process of adjusting a device, such as a monitor, so that it works consistently with others, such as a scanner or printer.

CCD (Charge-Coupled Device) A tiny photocell used to convert light into an electronic signal. Used in densely packed arrays, CCDs are the recording medium in most digital cameras.

Channel Part of an image as stored in the computer; similar to a layer. Commonly, a color image will have a channel allocated to each primary color (e.g. RGB) and sometimes one or more for a mask or other effects.

Clipping The effect of losing detail in the lighter areas of your image because the exposure was long enough for the photosites to fill (and record maximum values).

Clipping path The line used by desktop publishing software to cut an image from its background.

CMOS (Complementary Metal-Oxide Semiconductor) An alternative sensor technology to the CCD, CMOS chips are used in ultra-high resolution cameras from Canon and Kodak.

Color temperature A way of describing the color differences in light, measured in Kelvins and using a scale that ranges from dull red (1,900K), through orange, to yellow, white, and blue (10,000K).

Compression Technique for reducing the amount of space that a file occupies, by removing redundant data.

Conjugate The distance between the center of the lens and either the subject or the sensor.

Contrast The range of tones across an image from bright highlights to dark shadows.

Cropping The process of removing unwanted areas of an image, leaving behind the most significant elements.

Delta E A value representing the amount of change or difference between two colors within the CIE LAB color space. Industry research states that a difference of 6 or less is generally acceptable.

Depth of field The distance in front of and behind the point of focus in a photograph in which the scene remains in acceptably sharp focus.

Diffusion The scattering of light by a material, resulting in a softening of the light and of any shadows cast. Diffusion occurs in nature through mist and cloud cover, and can also be simulated using diffusion sheets and soft-boxes. See Soft-box.

Dynamic range A measure of image density from the maximum recorded density to the minimum, so an image with a DMax (maximum density) of 3.1 and a DMin (minimum) of 0.2 would have a dynamic range of 2.9. Dynamic range is measured on a logarithmic scale: an intensity of 100:1 is 2.0, 1,000:1 is 3.0. The very best drum scanners can achieve around 4.0.

Edge lighting Light that hits the subject from behind and slightly to one side, creating flare or a bright "rim lighting" effect around the edges of the subject.

Extension rings An adapter that fits into an SLR between the sensor and the lens, allowing focusing on closer objects.

Extraction In image editing, the process of creating a cut-out selection from one image for placement in another.

Feathering In image editing, the fading of the edge of a digital image or selection.

File format The method of writing and storing information (such as an image) in digital form. Formats commonly used for photographs include TIFF, BMP, and JPEG.

Filter (1) A thin sheet of transparent material placed over a camera lens or light source to modify the quality or color of the light passing through.

Filter (2) A feature in an image-editing application that alters or transforms selected pixels for some kind of visual effect.

Focal length The distance between the optical center of a lens and its point of focus when the lens is focused on infinity. Typically, 50mm is the 'standard' focal length for a 35mm or full-frame digital SLR camera.

Focal range The range over which a camera or lens is able to focus on a subject (for example, 0.5m to Infinity).

Focus The optical state where the light rays converge on the film or CCD to produce the sharpest image.

Fringe In image editing, an unwanted border effect to a selection, where the pixels combine some of the colors inside the selection and some from the background.

f-stop The calibration of the aperture size of a photographic lens.

Gamma (also written "C") A fundamental property of video systems which determines the intensity of the output signal relative to the input. When calculating gamma, the maximum possible input intensity is assigned a value of one, and the minimum possible intensity (no input) is assigned a value of zero. Output is calculated by raising input to a power that is the inverse of the gamma value (output = input (1/C)).

Graduation The smooth blending of one tone or color into another, or from transparent to colored in a tint. A graduated lens filter, for instance, might be dark on one side, fading to clear at the other.

Grayscale An image made up of a sequential series of 256 gray tones, covering the entire gamut between black and white.

Halo A bright line tracing the edge of an image. This is usually an anomaly of excessive digital processing to sharpen or compress an image.

Histogram A map of the distribution of tones in an image, arranged as a graph. The horizontal axis goes from the darkest tones to the lightest (on a scale of 0 to 255), while the vertical axis shows the number of pixels falling in that range.

HMI (Hydrargyrum Medium-Arc Iodide) A recently developed and popular light source for photography.

Hot-shoe An accessory fitting found on most digital and film SLR cameras and some high-end compact models, normally used to control an external flash unit.

HSB (Hue, Saturation, and Brightness) The three dimensions of color, and the standard color model used to adjust color in many image-editing applications.

Hue The pure color defined by position on the color spectrum; what is generally meant by "color" in lay terms. See also HSB (Hue, Saturation, and Brightness).

Inverter A device for converting direct current into alternating current.

ISO An international standard rating for film speed, with the film getting faster as the rating increases, producing a correct exposure with less light and/or a shorter exposure. However, higher speed film tends to produce more grain in the exposure.

Kelvin (K) Used to measure the color of light based on a scale created from the color changes that occur when a black object is heated to different temperatures. Normal midday sunlight is considered 5,000K. Lower temperature light (less than 5,000K) is more red or yellow, while higher temperature light is more blue.

Lasso In image editing, a tool used to draw an outline around an area of an image for the purposes of selection.

Layer In image editing, one level of an image file to which elements from the image can be transferred to allow them to be manipulated separately.

Local contrast The contrast range found in smaller areas of a scene or an image.

Luminosity The brightness of a color, independent of the hue or saturation.

Macro A mode offered by some lenses and cameras that enables the lens or camera to focus in extreme close-up.

Mask In image editing, a grayscale template that hides part of an image. One of the most important tools in editing an image, it is used to limit changes to a particular area or protect part of an image from alteration.

Megapixel A rating of resolution for a digital camera, related to the number of pixels output by the sensor. The higher the megapixel rating, the higher the resolution of images created by the camera.

Midtone The parts of an image that are approximately average in tone, falling midway between the highlights and shadows.

Modeling lamp Small lamp in some flashguns that gives a lighting pattern similar to the flash.

Monobloc An all-in-one flash unit with the controls and power supply built in. Monoblocs can be synchronized to create more elaborate lighting setups.

Noise Random patterns of small spots on a digital image that are generally unwanted, caused by non-image-forming electrical signals.

Pentaprism Abbreviation for pentagonal roof prism. This prism has a pentagonal cross-section, and is an optical component used in SLR cameras. Light is fully reflected three times, so that the image displayed in the viewfinder is oriented correctly.

Photomicrography Taking photographs of microscopic objects, typically with a microscope and attachment.

Pixel (PICture ELement) The smallest unit of a digital image—the square screen dots that make up a bitmapped picture. Each pixel carries a specific tone and color.

Plug-in In image editing, software produced by a third party and intended to supplement the features of a program.

ppi (pixels-per-inch) A measure of resolution for a bitmapped image.

Prime lens One with a fixed focal length. See also Zoom lens.

Rectifier A device for converting alternating current into direct current.

Reflector An object or material used to bounce available light or studio lighting onto the subject, often softening and dispersing the light for a more attractive end result.

Resampling Changing the resolution of an image either by removing pixels (lowering resolution) or adding them by interpolation (increasing resolution).

Resolution The level of detail in a digital image, measured in pixels (e.g. 1,024 by 768 pixels), lines-per-inch (on a monitor), or dots-per-inch (in a half-tone image at, for example, 1,200 dpi).

RGB (Red, Green, Blue) The primary colors of the additive model, used in monitors and image-editing programs.

Saturation The purity of a color, going from the lightest tint to the deepest, most saturated tone. See also HSB.

Selection In image editing, a part of an on-screen image that is chosen and defined by a border in preparation for manipulation or movement.

Sensitometer An instrument for measuring the light sensitivity of film over a range of exposures.

Shutter The device inside a conventional camera that controls the length of time during which the film is exposed to light. Many digital cameras don't have a shutter, but the term is still used as shorthand to describe the electronic mechanism that controls the length of exposure for the CCD.

Shutter speed The time the shutter (or electronic switch) leaves the CCD or film open to light during an exposure.

SLR (Single Lens Reflex) A camera that transmits the same image via a mirror to the film and viewfinder, ensuring that you get exactly what you see in terms of focus and composition.

Snoot A tapered barrel attached to a lamp in order to concentrate the light emitted into a spotlight.

S/N ratio The ratio between the amplitude of the signal (S) to be received and the amplitude of the unwanted noise (N) at a given point in a receiving system.

Soft-box A studio lighting accessory consisting of a flexible box that attaches to a light source at one end and has a diffusion screen at the other. A soft-box will soften the light and any shadows cast by the subject.

Spot meter A specialized light meter, or function of the camera light meter, that takes an exposure reading for a precise area of a scene.

TFT (Thin Film Transistor) A kind of flat-panel LCD with an active matrix for crisper, brighter color.

Tonal range The range of tonal values in an image. The histogram feature in an image-editing application displays tonal range. When an image has full tonal range, pixels will be represented across the whole of the histogram. Analyzing variation and deficiencies in the distribution represented in the histogram is the basis for making tonal corrections.

Telephoto A photographic lens with a long focal length that enables distant objects to be enlarged. The drawbacks include both a limited depth of field and angle of view.

Transformer A device that converts variations of current in a primary circuit into variations of voltage and current in a secondary circuit.

TTL (Through The Lens) Describes metering systems that use the light passing through the lens to evaluate exposure details.

Value A particular color tint. Also a numerical value assigned to a variable, parameter, or symbol that changes according to application and circumstances.

White balance A digital camera control used to balance exposure and color settings for artificial lighting types.

Index